THE AESTHETIC FUNCTION OF ART

The Aesthetic

CORNELL
UNIVERSITY
PRESS

ITHACA
&
LONDON

Function of Art

GARY ISEMINGER

Copyright © 2004 by Cornell University

First published 2004 by Cornell University Press

Printed in the United States of America

Library of Congress Cataloging-in-Publication Data
Iseminger, Gary.
 The aesthetic function of art / Gary Iseminger.
 p. cm.
 Includes bibliographical references and index.
 ISBN 0-8014-3970-1 (hardcover : alk. paper)
 1. Aesthetics. 2. Art—Philosophy. I. Title.
 BH39.I825 2004
 111'.85—dc22

 2004006696

Cornell University Press strives to use environmentally
responsible suppliers and materials to the fullest extent
possible in the publishing of its books. Such materials include
vegetable-based, low-VOC inks and acid-free papers that are
recycled, totally chlorine-free, or partly composed of nonwood
fibers. For further information, visit our website at
www.cornellpress.cornell.edu.

Cloth printing 10 9 8 7 6 5 4 3 2 1

CONTENTS

PREFACE

As someone interested in both philosophy and music, I was occasionally reproached for my apparent lack of interest in aesthetics. My excuse was that, perhaps in keeping with the low status of aesthetics in the philosophical pecking order of the late 1950s and early 60s, neither the undergraduate institution nor the graduate department at which I studied offered so much as a single course in aesthetics. I did not even have the opportunity to learn of the alleged dreariness of aesthetics.

At Carleton College, where I began teaching in 1962 and happily have remained, I became a colleague of Martin Eshleman, for whom aesthetics was central to philosophy and whose aesthetics course was legendary. We did not agree on much in philosophy, but he made it clear to me that aesthetics was a going concern, and, by the time he retired in 1968, I was happy to inherit the role of departmental aesthetician.

Of course, I had to find out something about the field, and I think it is fair to say in retrospect that what was "happening" then was what turned out to be the early stages of the continuing and multi-faceted conflict between Beardsleyan aestheticism and Dickiean institutionalism that did so much to shape what has come to be called "analytic aesthetics". This book is the outcome of my protracted attempt to come to terms with this conflict.

George Dickie's (I think mistitled) book *Art and the Aesthetic: An Institutional Analysis* (1974) came to crystallize the problem for me. I found his project of giving an institutional analysis of the concept of art very compelling but the idea that other crucial notions, especially that of the aesthetic, should also be understood in institutional terms considerably less so. (The title should have been *Art and the Aesthetic: Two Institutional Analyses.*)

One of my first published papers in aesthetics, "The Work of Art as Artifact" (1973), arose out of my dissatisfaction with Dickie's suggestion, in response to Morris Weitz's antiessentialist claim that "found art," such as a piece of driftwood, showed that even artifactuality was not a necessary condition for being a work of art, that the "status" of being an artifact could be "conferred," for example, by putting the driftwood on a mantle. In "Appreciation, the Artworld, and the Aesthetic" (1976) I explicitly proposed, as against Dickie, a noninstitutional account of the notion of an aesthetic property. My account of aesthetic properties in that paper turned out, on reflection, to be based on the sort of psychological notion that Dickie had objected to in the work of Monroe Beardsley, so I turned next to that topic. The result was "Aesthetic Appreciation" (1981). I was then diverted by reflections on Wimsatt and Beardsley's "Intentional Fallacy," during which time I occasionally wondered whether my intentionalist intuitions (*contra* Beardsley) were consistent with the fundamentally Beardsleyan position on the aesthetic that I found attractive.

I finally had occasion to begin to sort this out when I had the honor of being invited to give the Belgum Memorial Lectures in 1997 at St. Olaf College, just across the river (not to mention the main street, the state highway, and the tracks) from Carleton. The result was a fifteen-thousand-word typescript entitled "Aestheticism Defined and Defended," too long to be a paper and too short to be a monograph. I am deeply grateful to the philosophy department at St. Olaf for what is now over forty years of collegiality. (And thanks for the cigars, too.)

A selection from those lectures (Iseminger 1999), bearing the same title as the present book and presenting an early and truncated version of its argument, was read to the 1998 World Congress of Philosophy in Boston and appeared in its proceedings.

In 2000, I had the opportunity to teach a course on these issues in the department of philosophy of the School of Mental and Moral Science at Trinity College of the University of Dublin. (I wonder how Trinity's distinguished fellow George Berkeley would have regarded the tendency toward metaphysical profligacy evidenced by this name in the light of the facts that the department of philosophy is coextensive with the School of Mental and Moral Science and that Trinity College is coextensive with the University of Dublin.) This opportunity stimulated me to cast my ideas in something like the form they have taken here. Both students and faculty members at Trinity were helpful in forcing me to clarify what I wanted to say and what I was entitled to say.

Then, during a sabbatical in the spring of 2002, I enjoyed the hospitality of Peter Lamarque and the philosophy department of the University of York, where I was able to finish (in a loose sense of the word) the typescript.

Finally, during the fall of 2003, I was the guest of Stein Haugom Olsen and the philosophy department of Lingnan University in Hong Kong, where I really did finish the typescript.

This is not a scholarly book, but it depends crucially on the scholarship of others. I have borrowed wholesale from Larry Shiner's *The Invention of Art* (2001) and from Paul Kristeller's well-known historical reflections in "The Modern System of the Arts" (1951) and in his article "Origins of Aesthetics: Historical and Conceptual Overview" (1998) in the recent *Encyclopedia of Aesthetics* edited by Michael Kelly (1998). I have also relied on this excellent encyclopedia in my discussion of practices whose status as arts is recent, marginal, or contested. Since, as in Kristeller's case, the writers of the articles to which I refer generally are acknowledged experts in their fields, often summarizing their own authoritative publications, I do not think an apology for this reliance is required. Moreover, since what I am looking for in these cases is evidence of what people promoting these practices as arts thought it took for them to be arts, looking at articles about these practices in this recent major compendium of reflection on the arts seems an appropriate strategy. I sometimes reflect that one of the things that attracted me to philosophy was that it was possible to engage in it without being much of a scholar oneself, but it is not

possible to mount the kind of argument I defend in this book without somebody's being a scholar.

I am also grateful for particular suggestions, encouragement, and criticism (which they may not remember) to Piotr Boltuc, then of St. Olaf College and now of the University of Illinois at Springfield, Noël Carroll of the University of Wisconsin, Stephen Davies of Auckland University, Stan Godlovitch of Lincoln University, Garry Hagberg of Bard College, Dale Jamieson of Carleton College, Jerry Levinson of the University of Maryland, Paisley Livingston of Lingnan University, Justin London of Carleton College, Paul O'Grady of Trinity College Dublin, Charles Taliaferro of St. Olaf College, and my patient editor, Roger Haydon of Cornell University Press. Doubtless suggestions and comments by others whom I do not remember have also shaped this book.

As always, I am grateful to my wife, Andrea, for helping me to write better prose.

I have been enabled to satisfy my desire to do philosophy as well as to teach it through Carleton College's generosity as an institution, as represented particularly by President Steve Lewis, in whose name the chair I am honored to hold was given, and by dean of the college Beth McKinsey, and I have been sustained in that desire by the interest and support of my colleagues and students at Carleton over more than forty years. To it and to them I dedicate this book.

GARY ISEMINGER

Northfield, Minnesota

THE AESTHETIC FUNCTION OF ART

Introduction: Art and the Aesthetic

The Concept of Art and the Concept of the Aesthetic

The terms "philosophy of art" and "aesthetics" are often used interchangeably, which obscures two important facts: that the concept of the aesthetic and the concept of art are distinct concepts, each with its own history, and that it has become controversial how they are related to one another.

Some History

The introduction of the term "aesthetic" (from the Greek for "perceptual") into modern philosophical discourse is attributable to the mid-eighteenth century German philosopher Alexander Baumgarten, who defends a view of aesthetics as the science of "how things are to be cognized by means of the senses." Beauty enters into Baumgarten's account as "the perfection of cognition by means of the senses as such," and he discusses at length art—or rather, more specifically, poetry—as a source of beauty. Immanuel Kant follows Baumgarten's usage in part when he titles the section of the *Critique of Pure Reason*

in which he discusses the conditions of our cognitions of space and time "The Transcendental Aesthetic." He is not, however, impressed by Baumgarten's purported science of aesthetics, which he describes as an "abortive attempt . . . to bring the critical treatment of the beautiful under rational principles," noting that "the Germans are the only people who currently make use of the word 'aesthetic' to signify what others call the critique of taste" and evidently resolving not to follow the (other) Germans in this. Nonetheless, Kant, in his *Critique of Judgment,* while eschewing the term "aesthetic" in this connection, continues to pursue a general project that may be described as the search for a distinctive state of mind connected with the apprehension of a distinctive kind of value, both characteristically, though not exclusively, connected with art.

Just as anyone who reads Kant's "Transcendental Aesthetic" will quickly recognize that Kant is not using the term "aesthetic" in its contemporary sense, anyone who reads Plato's discussions of the "art" of the carpenter, the shoemaker, or the statesman will know that Plato is not deploying the modern concept of art—that is, the concept of a genus of which at least music, the visual arts, and literature are species, while, for instance, rhetoric, astronomy, and philosophy are not. Though there is a long history of comparisons among the arts, dating back at least to Horace's remark that a poem is like a picture ("*ut pictura poesis*"), Kristeller (1951) has argued that it was not until the middle of the eighteenth century, when Baumgarten was introducing the concept of the aesthetic into philosophy, that what he calls "the modern system of the arts," comprising (at that time) music, poetry, painting, sculpture, and dance, was codified by Charles Batteux in *Les beaux-art réduit à un même principe* and broadly accepted in Western Europe.

A Controversy

At least by the late eighteenth century, then, the crucial conceptual elements were in place for the question "What exactly is the relation between art and the aesthetic?" to arise. The question was perhaps not clearly posed at that time because, though the concepts

are distinct, their origins and early development seemed naturally to lead to a view of their connection that may broadly be called *aestheticism*—the view that art is essentially the bearer of a distinctively aesthetic kind of value, of which beauty is a prime example, that is revealed by or realized in a characteristically aesthetic state of mind.

Accordingly, succeeding philosophers in various Western traditions and of various persuasions have identified a perhaps embarrassingly rich variety of putative aesthetic states of mind, connecting them more or less closely with art as characteristically, if not exclusively, their object or source, and suggesting that the value of a work of art is revealed by, or perhaps even constituted by, its capacity to be such an object or source.

Aestheticism has, however, become controversial, not only because of the perceived dubiousness of the psychology (not to mention the metaphysics and value theory) that typically are fundamental to it but also because of developments in the arts and the theory of the arts that lead many to regard aestheticism as politically or ideologically suspect.

My aim in this book is to defend a version of aestheticism. My strategy will be first to set out in outline the most philosophically sophisticated version of aestheticism developed during the latter half of the twentieth century, that of Monroe Beardsley, which exemplifies what I shall call *traditional aestheticism*, a view that is supported by compelling intuitions but has been subjected to powerful objections. With the aim of honoring those intuitions while meeting those objections, then, I will propose, explain, and defend a *new aestheticism*.

Traditional Aestheticism

Victorian Aestheticism and Traditional Aestheticism

The term "aestheticism" has been popularly used to identify a movement among artists and critics in Victorian England—figures such as Walter Pater, James Whistler, and Oscar Wilde—who rallied around the ambiguous but stirring slogan, borrowed and translated from earlier French writers, "art for art's sake." In general this slogan was used to promote claims that a work of art should be valued for those of its properties, often chiefly formal ones, that were revealed in an intense experience of the work itself, as distinct from any useful function it might perform or any moral, political, or religious values it might express or embody. Such a view, emphasizing the independence of the distinctive value of works of art as compared with other values, naturally tended to such extremes as the thought that this value was not only independent of such other values but even superior to them. As flamboyantly promoted by Wilde, it was lampooned in Gilbert and Sullivan's operetta *Patience* and came to exemplify for some the presumed decadence of the fin de siècle.

What I mean by "traditional aestheticism," though having affinities with the Victorian version, to which it can to some extent trace its lineage, is, however, a view more often defended by philosophers than promoted by publicists, rooted in philosophical tradition more firmly than in any cultural movement, and in general pursuing such traditionally essentialist philosophical aims as defining art and formulating criteria of value for works of art.

Beardsley's Aestheticism

The fullest and most carefully worked out expression of traditional aestheticism in recent twentieth century English-speaking philosophy is to be found in the writings of Monroe Beardsley. In discussing his work, my main concern is to exhibit the general structure of typical efforts in the traditional aestheticist vein. Accordingly, I will not be able to do justice to the subtlety of Beardsley's thinking. Here, as in other areas of aesthetics, his work has been of fundamental importance for English-speaking philosophers, in this case because it first presented a traditional view in such a carefully worked out and clearly stated way that it virtually demanded discussion with the techniques and in a manner characteristic of recent English-speaking philosophy in general.

Beardsley's definition of a *work of art*, ignoring some subtleties that are not relevant to the current discussion, is that

> a work of art is . . . an arrangement of conditions intended to be capable of affording an experience with marked aesthetic character. (Beardsley 1982, 299)

His account of *aesthetic value* is that

> The aesthetic value of X is the value that X possesses in virtue of its capacity to provide aesthetic gratification when correctly experienced. (Beardsley 1982, 26)

In the first quotation above, the connection between the concept of a work of art and the concept of the aesthetic state of mind is claimed

to be a conceptual one. Something's being a work of art is defined—its logically necessary and sufficient conditions specified—in terms of the thing's being intended to have the capacity to afford an aesthetic experience. Given this essentialist ambition, it is crucial, on pain of circularity, that Beardsley's account of the aesthetic experience (or, as he sometimes calls it, as in the second quotation, "aesthetic gratification," "aesthetic satisfaction," or "aesthetic enjoyment") not appeal to any prior understanding of the concept of art, and so it does not. It is ultimately

> the presence in the object of some notable degree of unity and/or the presence of some notable intensity of regional quality that indicate that the enjoyments or satisfactions it affords are aesthetic. (Beardsley 1982, 23)

Now the adjective *aesthetic* has a way of spreading once it is turned loose, replicating itself in phrases identifying what Noël Carroll has somewhat disparagingly referred to as "aesthetic what-not." (Note that I have already introduced, in addition to various accounts of different aesthetic states of mind, the concept of aesthetic value.) In the same spirit, we might say that what has turned out to be conceptually basic in Beardsley's scheme is not some aesthetic state of mind but rather what it would be natural to call aesthetic properties (or descriptions, concepts, or terms). It might be useful to say this if part of one's ambition was to give an account of the structure of what might be called "aesthetic space," relating various ideas of aesthetic this-or-that to one basic idea of aesthetic something-or-other. In any event, Beardsley here aspires to enter aesthetic space from outside; his account of the relevant qualities does not presuppose any prior idea of the aesthetic. The definition of the aesthetic he offers is in an important sense reductive.

(I note in passing, in fairness to Beardsley, that he discusses at length the crucial ideas of unity, intensity, and regional qualities invoked in his account of aesthetic enjoyment. Since I am mainly concerned with treating Beardsley's view as an example of the structure of traditional aestheticism, I am ignoring details and perhaps giving the false impression that Beardsley's view is intensely abstract and re-

moved from contact with real experience and the real life of the arts. Nothing could be further from the truth.)

Equally, even though he does say that the experiences (gratifications, enjoyments, satisfactions) whose character he aims to discern can be identified as those that are "characteristically and preeminently provided by . . . certain clear-cut exemplary cases of works of art," he also does not appeal to any prior concept of art to enter aesthetic space; the reduction is not to the concept of art. The experiences in question are identified extensionally; they are the experiences characteristically and preeminently provided by "poems, plays, musical compositions, and so forth" (Beardsley 1982, 22), and we need no concept of art or of the aesthetic to identify paradigm instances of them.

Notice, too, that his account of aesthetic value does not explicitly connect aesthetic value and the value of works of art. It is, moreover, clear that in Beardsley's view there is no reason to suppose that only works of art can afford aesthetic experience and thus have aesthetic value. Nonetheless, given that for Beardsley a work of art is by definition something intended to produce aesthetic experience and that having aesthetic value is having the capacity to produce such experience, it would seem fairly straightforward to infer that the value of a work of art as a work of art is its aesthetic value, that is, its capacity to produce aesthetic experience. For it is reasonable to suppose that one ought to judge the value of a thing intended to have a certain capacity in terms of its having or not having that capacity. (If a nail file is something intended to have the capacity to smooth fingernails, then its value as a nail file is directly correlated with its having that capacity.) So the implication that the distinctive value of a work of art as a work of art is its aesthetic value seems clear.

Recent discussion, following Stephen Davies (1991), has been informed by a distinction between *functional* and *procedural* definitions of art, with Beardsley as a prime exemplar of functionalism. Though it may not directly follow from the fact that something is intended to have a capacity to do something that its function is to do it, the connection between these two ideas is very close. (It would be natural to say that a nail file's function is to smooth fingernails, and

one reason for saying that would be that the nail file was intended to have the capacity to smooth fingernails.) The concept of a function is discussed in more detail in Chapter 5, but for the moment this connection between intended capacity and function is enough to motivate expressing something like Beardsley's definition of art in functional terms. (The paradox of taking a definition of art in terms of its function as representing a view traditionally hostile to the idea that art has a function is merely apparent, for the function of affording aesthetic experience is not a function to which aestheticists object. Taking that function as central to art is to heed rather than to contravene the injunction to value art "for its own sake.")

Finally, it seems appropriate to make a point that Beardsley recognizes when he adds the qualification "when correctly experienced" to his definition of aesthetic value. It might turn out that whatever we identified as the characteristic experience afforded by poems, pictures, plays, musical pieces, etc., could be produced in ways that circumvented the need to attend carefully to such things—by drugs, for example, or by electrodes inserted in the brain. We presumably would not want to conclude that the pill or the electrode was aesthetically valuable in the way a great painting or a marvelous natural scene was; they might cause aesthetic experiences, but they would not afford them, in the sense of providing such experiences to someone who carefully and knowledgeably attended to the pill or the electrode. I shall, in a somewhat legislative spirit, then, use the phrase "afford aesthetic gratification [an aesthetic experience, aesthetic satisfaction, etc.]" as equivalent to "provide aesthetic gratification [an aesthetic experience, aesthetic satisfaction, etc.] when correctly experienced."

I propose, then, to identify traditional aestheticism with two necessary and sufficient condition claims inspired by, though perhaps not exactly equivalent to, Beardsley's definitions of the work of art and of aesthetic value: first, a *functional* thesis,

> (F) Something is a work of art if and only if its function is to afford aesthetic experience,

and next a *valuational* thesis,

(V) A work of art is a good work of art if and only if it has the
capacity to afford aesthetic experience.

These two theses exhibit the fundamental characteristics of aes-
theticism. They proceed from the recognition of a clear distinction
between art and the aesthetic (this latter conceived of psychologi-
cally) while linking them closely to one another (by definition, in
fact), even as they allow for the existence of the aesthetic in the ab-
sence of art (i.e., things that do not have the function of affording aes-
thetic experiences may still do so), and they explain the value of art
in terms of the aesthetic.

Aestheticist Intuitions

What can be said for traditional aestheticism so conceived? In gen-
eral, what can be said for a substantive philosophical proposal of this
sort typically takes either the form "It explains such-and-such intu-
itions," where an intuition is a prereflective commonplace that might
plausibly be taken to be sufficiently obvious that any theory that
failed to accommodate it would ipso facto lose credibility, or the
form, "It avoids such-and-such problems," where a problem is an ar-
gument purporting to show that the proposal in question cannot ac-
commodate some relevant intuition or, perhaps, contradicts itself, is
circular, or commits some other formal indiscretion.

The intuitions that traditional aestheticism undertakes to honor
typically consist of commonplaces about art, and traditional aes-
theticism's claim is that the notion of the aesthetic experience, as ap-
pealed to in (F) and (V) above, explains these intuitions. (The full
import of these intuitions and the efficacy of the appeal to aesthetic
experience in accommodating them depend, of course, on exactly
how art and the aesthetic are finally conceived, something that will
not be clear until later. Perhaps one should imagine each occurrence
of the words "art" and "aesthetic" in the next few paragraphs as fol-
lowed by the cautionary phrase "in some sense" for now. This will
not do indefinitely, of course.)

1. There is a close connection between art and the aesthetic. One basic intuition is that art and the aesthetic are indeed importantly linked with one another. Even those who try to put art to other uses—political, religious, ideological—seem bound to admit that there is some such connection. Traditional aestheticism honors this intuition, that there is a close connection between art and the aesthetic, in a strong and direct way by defining art in terms of the aesthetic.

2. Experiencing a work of art is necessary for appreciating it. Another intuition is the thought that the only way truly to grasp a work of art is by experiencing it. Pictures are to be seen; musical pieces, to be heard; poems, to be read. Knowing a lot about a work—having what in an earlier terminology was called "knowledge by description"—may be useful, indeed indispensable, but only "acquaintance" with the work, however such acquaintance may be mediated and qualified by what we may know about that work, puts us in a position to understand, to appreciate, and to judge it. In accordance with this intuition, traditional aestheticism's functional definition of art, together with the thought that truly to understand, appreciate, and judge a functional object one has to try it out to see if it performs its function, implies that to grasp a work of art one must confront it in a way that constitutes "trying it out" to see if it does what it is supposed to do; in this case, afford aesthetic experience, which requires that we look at it, or listen to it, or read it, or etc.

3. There is a distinction between artistically relevant and artistically irrelevant properties. Yet another important intuition is that there are some ways of regarding art that involve not truly treating it as art. Hence, grasping properties disclosed only when a work is regarded in such ways would not be directly relevant to understanding or evaluating the work as a work of art. To regard a work of art only as an investment, for example, is not to regard it as art, and, correlatively, understanding its properties as an investment is not directly relevant to understanding it or evaluating it as a work of art. Traditional aestheticism's functional account of art provides at least a general form for approaching the question whether a certain property is thus relevant or irrelevant to a work of art as art. Is it or is it not a property that contributes to the function of affording aesthetic experience? A work's investment value evidently is not, while its formal

qualities (e.g., of design) plausibly are, so that, in contrast to the latter, the former is, we might say, irrelevant to it as art.

4. The criterion of artistic value follows from the nature of art. Finally, there is a long tradition of expecting to be able to understand what makes something of a certain kind better or worse in terms of understanding what kind of thing it is. When we know what something (say, a certain metal implement) is (say, a nail file), then we can infer a principle for deciding how good it is (see how well it smooths fingernails). This inference from something's nature to a criterion of value for it is, of course, particularly straightforward when the thing is an artifact that is defined in terms of its function. In the present case this tradition finds expression in the intuition that the criterion of artistic value follows from the nature of art.

Traditional aestheticism supports a particularly transparent inference from its account of art's nature (F) to its criterion of artistic value (V). All that is required to license this inference is the plausible principle that if something's nature consists in having a certain function, then it is good as a thing having that nature just in case it can fulfill that function.

These claims on behalf of traditional aestheticism may be summarized thus: Traditional aestheticism accounts for the clear and strong connection between art and the aesthetic; explains why experiencing a work of art is crucial for understanding and appreciating it; underwrites a criterion for distinguishing between those properties of works of art that are relevant and those that are irrelevant for appreciating them as works of art; and, on the basis of its account of the nature of art, provides a principle of value in art.

Objections to Aestheticism

Traditional aestheticism is not, however, a currently popular view, even among those who share the intuitions that it is designed to accommodate. It is subject to a variety of objections that, in the view of many (probably a significant majority of) contemporary aestheticians, decisively refute it. (My initial account of these objections will proceed at a level of generality comparable to that of my account of

the view itself and of the intuitions to which it is sensitive; at this point my aim is to describe them generally to catch their flavor and suggest their plausibility.)

1. *The antiessentialist objection.* The most fundamental of these is the antiessentialist objection. Morris Weitz has famously adapted Ludwig Wittgenstein's discussion of the concept of a game as a family resemblance concept to the concept of art, arguing that

> aesthetic theory is a logically vain attempt to define what cannot be defined, to state the necessary and sufficient properties of that which has no necessary and sufficient properties, to conceive the concept of art as closed when its very use reveals and demands its openness. (Weitz 1956, 30)

Weitz not only assembles plausible counterexamples to the most popular accounts of the necessary and sufficient conditions of something's being a work of art extant when he wrote but also advances a thesis intended to show why such counterexamples are possible and will always be possible no matter what new proposals might be offered for those conditions:

> The very expansive, adventurous character of art, its ever-present changes and novel creations, makes it logically impossible to ensure any set of defining properties. (Weitz 1956, 32)

If Weitz is right about this, traditional aestheticism as I have formulated it, including, as it does in principle (F), a claim about the "defining properties" of art, cannot be correct.

Traditional aestheticism may not be as explicitly committed to an essentialist account of aesthetic experience as it is to an essentialist account of art, but it would not be surprising to find the essentialist impulse of traditional aestheticism also finding expression in attempts to give necessary and sufficient conditions for being aesthetic-something-or-other, indeed, most often for being an aesthetic state of mind—aesthetic pleasure, aesthetic appreciation, aesthetic contemplation, the aesthetic attitude, the aesthetic experience, etc. Nor is it any more surprising that the antiessentialist impulse of early readers of the later Wittgenstein should be applied to attempts to define the

aesthetic state of mind as well as to attempts to define art. A notable example is Marshall Cohen, who suggests that even though, despite arguments like Weitz's,

> the notion lingers . . . that if there is no property common to all works of art there may yet be some property or properties common to our proper experience of these works of art . . . ,

there is, nonetheless,

> no reason to believe [that] any property [is] essential to aesthetic experience. (Cohen 1962, 486)

Cohen appeals to general Wittgensteinian reflections on the importance of recognizing that many concepts do not have essential conditions and "looking and seeing" whether or not this is the case for any concept we propose to analyze, but he does not have an argument, comparable to Weitz's argument from the "the very character of art," that it is in the very nature of the concept of the aesthetic to resist definition. What Cohen does is to scrutinize candidates for the fundamental aesthetic state of mind and, in effect, convict their defenders of failing to "look and see" how the crucial concepts really work. Regarding the suggestion that contemplation, for example, is the essential aesthetic state of mind, he says,

> If one ought to contemplate a Redon or a Rothko, one ought to scrutinize the Westminster psalter, survey a Tiepolo ceiling, regard a Watteau, and peer at scene of Breughel. If we attend to these distinctions, we shall be in a position to deny that we must contemplate these works in order to have a proper aesthetic experience of them. (Cohen 1962, 490–91)

If every proposal for the aesthetic state of mind can thus be undermined by careful "looking and seeing," the search for the essence of the aesthetic experience is as misguided as the search for the essence of art, and to the extent that principle (F) depends on essentialist commitments with respect both to art and to the aesthetic, it is doubly damned.

2. *The institutionalist or antifunctionalist objection.* Waiving for the moment antiessentialist objections to (F), it is still possible to object to the particular character of the definition it expresses. I observed earlier that Davies (1991), distinguishing between functional and procedural definitions of art, takes traditional aestheticism, as exemplified by Beardsley, as a prime instance of a functional definition. As "the most convincing version of a procedural approach to the definition of art" Davies proposes George Dickie's "institutional theory" (Davies 1991, 38), which in one early form defined art in this way:

> A work of art . . . is (1) an artifact (2) a set of the aspects of which has had conferred upon it the status of candidate for appreciation by some person or persons acting on behalf of a certain social institution (the artworld). (Dickie 1974, 34)

The phrase "an artifact" in Dickie's definition seems to be speaking to the same concerns that led Beardsley to include the phrase "an arrangement of conditions" in his, so they can perhaps be regarded as canceling one another out in any comparison between the two. The question may then at first appear to be whether something is a work of art because of what it does to somebody (e.g., provide aesthetic experience) or because of what somebody has done to it (e.g., put it in a museum). But this seemingly straightforward contrast is complicated first because in Beardsley's case the concept of function enters by way of what an "arrangement of conditions" is intended to have the capacity to do to somebody, so that in his view a work of art may still be a work of art even though twice-removed from actually providing aesthetic experience, which it may fail to do either because it lacks the capacity to do so or because that capacity is never exploited. From the other side of the contrast, "what somebody has done" to a work of art admits of interpretations lacking the "institutional" feature that distinguishes Dickie's theory—"what somebody has done to it" evidently might include making it or looking at it, for instance, without that person having acted on behalf of any social institution, formal (a museum) or informal (the artworld). The most we can perhaps say is that, in contrast to Dickie's definition, Beardsley's is *non-*

institutional in that evidently someone who "arranges" some "conditions" with the intention that they have the capacity to afford aesthetic experiences can do so independent of any social practice or institution membership or officership in which would empower people to confer on that "arrangement" a status that it could not enjoy absent such conferral.

This is enough, however, to generate a second objection to traditional aestheticism. It is a commonplace that there is an artworld, an informal institution comprising people concerned with the practice of art, in which various members have various roles and in those roles can sometimes have the power to confer status. This is perhaps obvious in the case of formal institutions that are part of the artworld, such as art schools, whose officers have the power to confer the B.F.A. degree on their graduates. But it is equally, and more interestingly, true that, for example, an influential critic may have the power to confer on an artist some such status as "the doyen of contemporary realist painters." Not just anybody could do that, and the critic cannot do it merely by uttering an appropriate sentence, but, given the right circumstances, an artist may have some such status (at least in part) because a critic said so. I shall have much more to say about the practice of art and the artworld in Chapter 4, but this is enough to raise the possibility that something is a work of art because it has had some status conferred on it in something like the same sense, perhaps by artists, who somehow have the power to confer it. If, however, to be a work of art is to enjoy a status that is dependent on a social institution that empowers people to confer that status, then the traditional aestheticist's definition of art, satisfiable, as it evidently is, independent of any such institution, must be wrong.

3. *The antipsychological objection.* Supposing that this objection, too, can somehow be neutralized, and that we can thus continue to see ourselves as searching for something like the function of a work of art, what reason is there to suppose that this function is to be explicated in terms of the work's relation to a distinctively aesthetic state of mind (e.g., its being intended to produce such a state of mind when correctly experienced)?

Clive Bell, who, though evidently not anxious to be associated with Victorian aestheticism, had ample opportunity to learn from it, faced

this question and gave an uncompromising, but equally unconvincing, answer:

> The starting point for all systems of aesthetics must be the personal experience of a peculiar emotion. The objects that provoke this emotion we call works of art. All sensitive people agree that there is a peculiar emotion provoked by works of art. (Bell 1914, 61)

One hears the sound of two hands waving. That there is no such state of mind—no "aesthetic emotion," "aesthetic experience," "act of distancing," "aesthetic pleasure," "aesthetic attitude," "intransitive attention,"—that is at once phenomenologically distinctive, introspectively discernible, and capable of plausibly doing duty as the fundamental notion in an account of the realm of the aesthetic and thereby in a definition of art, is the burden of a series of articles by Dickie, whose generally deflationary tone is exemplified by the title of the original version of the one most salient to my purposes, "Beardsley's Phantom Aesthetic Experience" (Dickie 1965).

Even though Dickie has published similar animadversions on virtually every variation on the notion of a characteristically aesthetic state of mind, a brief account of parts of the long series of exchanges between Beardsley and Dickie on this issue must suffice to give some sense of it. Beardsley initially describes the aesthetic experience as one that, as a result of one's "attention . . . [being] firmly fixed upon heterogeneous but interrelated components of a phenomenologically objective field," is unified (in being both coherent and complete), intense, and complex to a high degree (Beardsley 1958, 527–28). Dickie (1965) grants that items on which one's attention is fixed can have these qualities, but argues that the attempt to characterize the experience itself as unified, intense, and complex, far from being introspectively certifiable, is simply an instance of the familiar mistake of confusing an experience of something that has certain qualities with an experience that itself has those very qualities.

In reply, Beardsley (1969) insists that he can indeed distinguish, for example, a complete experience from an experience of completeness and offers a somewhat more formal account of the aesthetic experience:

> A person is having an aesthetic experience ... if and only if the
> greater part of his mental activity ... is united and made pleasurable
> by being tied to the form and qualities of a sensuously presented or
> imaginatively intended object on which his primary attention is con-
> centrated. (Beardsley 1969, 5)

In response, Dickie (1974) concedes that an experience, as distinct
from its objects, can be unified but suggests that unity is not neces-
sary for the experiences characteristic of our intercourse with works
of art, so that even if there are phenomenologically distinctive expe-
riences of the sort Beardsley seeks to describe, they are not related to
art in a way that traditional aestheticism can exploit. The only way
to identify the experiences characteristic of our intercourse with art
is as just that—that is, by reference to their objects, works of art. The
strategy of the antipsychological objection thus becomes clear; tradi-
tional aestheticism cannot both identify a distinctively aesthetic
state of mind and, at the same time, give an account of art in terms
of it. (It is worth mentioning, however, that the controversy between
Dickie and Beardsley does not end here, and, as the passages quoted
earlier from Beardsley [1982] show, Beardsley remained a somewhat
chastened but fundamentally unrepentant aestheticist.)

 4. *The antiformalist objection.* Yet again, even supposing that the
antiessentialist, antifunctionalist, and antipsychological objections
can somehow be evaded, accommodated, or refuted, even a presum-
ably defensible account of the aesthetic state of mind may still raise
problems for traditional aestheticism when such an account is cou-
pled with an attempt to explain art in terms of that aesthetic state of
mind in the manner of (F).

 One way to see the problem is to reflect on where the line men-
tioned earlier between artistically relevant and artistically irrelevant
properties might be drawn. As I remarked, traditional aestheticism
provides a principle for determining whether or not a certain property
is artistically relevant. Is it or is it not a property whose function is
to afford an aesthetic experience? However that experience is con-
ceived, it seems clear that it is not the function of a work's monetary
value to provide it; a work of art is not, for instance, meant to gratify
us as a work of art in virtue of our reflecting on how much it is worth.

In contrast, it is plausible to suppose that works of art are meant to gratify us as works of art in virtue of our experiencing such qualities of them as their unity (to take one of Beardsley's examples.)

There are, however, many types of properties that works of art may exemplify that are somewhere "in between" the *economic* property of monetary value and such *formal* properties as unity in the sense that it may be less obvious whether or not they are artistically relevant—that is, whether or not grasping those properties is crucial to understanding works of art that exemplify them as works of art and whether or not having or lacking those properties is directly relevant to works that exemplify them being better or worse as works of art.

Works of art, for example, may have the following types of properties (this list is neither exhaustive nor exclusive):

- *physical* (being rectangular, weighing 23 pounds, lasting 4 minutes and 33 seconds)
- *expressive* (being sad, hopeful, joyous, or angry)
- *representational* (depicting a crucifixion, a storm in the country, a battle, or a slice of urban life)
- *semantic* (saying that life is absurd, that women are fickle, that love conquers all, that God is great)
- *genetic* (being inspired by a love affair, arising out of the social conditions of the Depression)
- *causal* (igniting a riot in Paris in 1914, recalling Chinese painting, brightening the listener's day)
- *art-historical* (being original, inspiring imitators, being influenced by Bach)
- *stylistic* (being Mannerist, being Romantic)
- *generic* (being a sonnet, being a novel, being a symphony)
- *ideological* (being an endorsement or an indictment of Stalinism or of late bourgeois capitalism)

Where do the principles of traditional aestheticism leave us as regards the artistic relevance of properties of these kinds? Suffice it to say at this point that there is a strong tendency for these principles to favor the judgment that a property is artistically irrelevant in the sorts

of intermediate cases just instanced, so that traditional aestheticism often results in a kind of formalism. This tendency is strikingly illustrated by Bell, who says that what evokes in us the "aesthetic emotion" are the "relations and combinations of lines and colors" (he is speaking only of the visual arts) that he calls "Significant Form" and claims that "to appreciate a work of art we need bring with us nothing from life, no knowledge of its ideas and affairs, no familiarity with its emotions" (Bell 1914, 62, 68).

One way in which traditional aestheticism results in formalism depends on describing the aesthetic state of mind in a way that makes it distinct from more "ordinary" states of mind and perhaps difficult to attain in the face of their "distractions." (Bell, for instance, speaks of being transported from "the world of man's activity to a world of aesthetic exaltation," being "shut off from human interests; our anticipations and memories . . . arrested; lifted above the stream of life" (Bell 1914, 68). Beardsley, though convinced finally by Dickie that the aesthetic experience as he had originally conceived it was indeed too "special" to be a general account of our encounters with works of art, still insisted in his final account of aesthetic experience that it typically involved, among other things, "a sense of release from the dominance of some antecedent concerns about past and future, . . . a sense that the objects on which attention is concentrated are set a little at a distance emotionally, . . . [and] a sense . . . of being restored to wholeness from distracting and disrupting influences" (Beardsley 1982, 288–89).

Thinking of the aesthetic state of mind as thus competing for mental space, so to speak, with "ordinary" states of mind can thus encourage reflections of the following sort. "If I start thinking about how much money this work is worth (or what its creator was thinking, or what a fuss it caused when it was first exhibited, or how many other people had or had not created something like it earlier or did or did not do so under its influence, or what it represents or expresses, or what its creator's politics were, etc.), there won't be room in my mind for the savoring of those formal properties it has that undoubtedly afford aesthetic experience. So I must try to ignore everything but its formal properties if I want to make my mind available for aes-

thetic experience. And if the point of art is to afford aesthetic experience, it follows that any other (nonformal) properties of the work are irrelevant to it as art."

Now this is undoubtedly a gross caricature of an "argument" for a kind of formalism. Even taken at face value, it is clearly much more plausible for some of these properties than for others that consideration of them will "drive out" appreciation. (Beardsley, for instance, thinks of matters in something like Bell's way, but he does not carry it to the extremes that Bell does. His "regional qualities," for example, include expressive properties.) But the idea of aesthetic experience as the point of art may well promote formalism about art in something like this way.

The antiformalist objection, as it may be called, can now be stated. Formalism, particularly of the extreme sort Bell exemplifies, is an impoverished and inadequate view of what matters in works of art. For many, if not all, kinds of properties that an argument of the kind just adumbrated dismisses as irrelevant to understanding, appreciating, and evaluating art, it seems mad to suppose that we could fully grasp a work that exemplified them without understanding that it did. Surely if a piece of music, say, starts as a typically energetic Shostakovichian symphonic finale but then builds to an over-the-top frenzy of apparent rejoicing that makes what seems at first to be its glorification of Stalinism ring hollow, and I do not recognize this, then I have not fully appreciated it. If theories that tie aesthetic experience to the nature and value of art in the way traditional aestheticism does in theses (F) and (V) imply the contrary, so much the worse for them.

5. *The antiexperientialist objection.* Suppose, however, that an account of the aesthetic experience could be given that did not have unacceptably formalistic consequences when combined with an account of how that experience is central to art. The *antiexperientialist objection* cuts even deeper. Even if there is an appropriately rich kind of experience that much art aims to afford, aren't there examples of works of art whose point and value is obviously and avowedly independent of its capacity to afford such an experience? Here the objector might mention such "conceptual" works as Marcel Duchamp's *L.H.O.O.Q.* and *L.H.O.O.Q. Shaved*, the former a copy of a cheap reproduction of Leonardo da Vinci's *Mona Lisa* with a mustache and

goatee crudely drawn on it, the latter simply a copy of the cheap re-
production untouched. Don't such works, apparently not affording
nor intended to afford anything like aesthetic experience, stand as
straightforward counterexamples to thesis (F) of traditional aestheti-
cism? In a somewhat different way, aren't the religious aims of a Jo-
hann Sebastian Bach or the political aims of a Bertolt Brecht—aims
so often professed by artists and evident in their works—evidence
that art often has functions that go beyond and are arguably more
important than providing aesthetic "highs"—"eye candy" or "ear
candy"—for the cognoscenti?

6. *The absent artist objection.* Finally, there is what might be called
the absent artist objection. Even if all the difficulties just mentioned
can be surmounted, it is still the case, it might be claimed, that the
aestheticist view of art is inherently biased toward the spectator or
audience. Granted that its functional thesis (F) appears to concede, at
least by implication, *sub voce* and in the passive, that a work of art is
intended (by whom?) to have the property that makes it a work of art,
still that crucial property is a capacity to provide something for an au-
dience. This capacity is, moreover, shared by things (e.g., scenes of
natural beauty) that are evidently not intended to have it. What of the
artist and the creative process? If the only thing that a theory says
about the difference between art and nature in their respective rela-
tions to the aesthetic is that in the former case what can afford aes-
thetic experience is intended to do so while in the latter it can do so
without being so intended, that theory seems to have failed to cap-
ture something about the nature of art, even if it should be able to ac-
commodate or refute the counterexamples lately mentioned and
perhaps achieve extensional adequacy. At best, it is a lopsided and in-
complete account of art that needs to be supplemented by a serious
consideration of the role of the artist.

The objections to traditional aestheticism may be summarized this
way: Art has no essence. Even if it does, that essence is to be defined
procedurally rather than functionally. Even if a functional definition
is not to be ruled out a priori, the alleged characteristically aesthetic
state of mind or experience appealed to in traditional aestheticism's
functional definition is bogus. Even if that state is not bogus, that ap-
peal brings with it unacceptably formalistic views of the understand-

ing of art and of the distinction between the artistically relevant and the artistically irrelevant. Even if it doesn't do that, the emphasis on the provision of aesthetic experience ignores what might be called antiaesthetic art (Duchamp) and hyperaesthetic art (Brecht). Finally, even if traditional aestheticism can accommodate these kinds of art, its emphasis on the audience involves a systematic slighting of the role of the creative artist.

The Project

Traditional aestheticism not having been formulated in anything but a general way, this tally of the intuitions it honors and the objections it invites must remain for now equally superficial. Although I have by no means demonstrated that any adequate account of the connection between art and the aesthetic must preserve these intuitions nor that every version of traditional aestheticism must fall to these objections, I shall assume that the intuitions are plausible and the objections weighty. In the next chapter I propose and begin to explain and defend a new version of aestheticism that aims to honor the intuitions and avoid the objections.

A New Aestheticism

A Variation on Aestheticism

I shall defend a variation on traditional aestheticism. Corresponding to but distinct from (F), the functional thesis of this new aestheticism is

(F') The function of the artworld and practice of art is to promote aesthetic communication.

Instead of (V), the valuational thesis of this view is

(V') A work of art is a good work of art to the extent that it has the capacity to afford appreciation.

The Aestheticist Intuitions and the Objections to Aestheticism

The gradual explication and ultimate defense of theses (F') and (V') constitute the main agenda for the rest of this book. Even at this early

stage, however, it is possible to outline how they will speak to aestheticist intuitions and objections to aestheticism.

The first thing to note is that (F′) is not, like (F), a claim concerning the logically necessary and sufficient conditions for being a work of art, both because it is not a claim about works of art and because it is not a claim concerning logically necessary and sufficient conditions. It is about the *practice* of art and the *informal institution* of the artworld lately invoked in the statement of the institutional objection to traditional aestheticism. Nor is it a claim concerning the logically necessary and sufficient conditions of a practice's being the practice of art or an informal institution's being an artworld, but rather a claim concerning the function that this practice and this informal institution as a matter of fact fulfill.

The antiessentialist objection is thus rendered powerless to the extent that it is based on antiessentialism specifically about the concept of a work of art. But that minor victory is achieved only by changing the subject, and it may still be the case that more general Wittgensteinian considerations can be mobilized against any attempt to give the necessary and sufficient conditions of a practice's being an artistic practice or an institution's being an artworld. Further, Morris Weitz's remark about the "expansive, adventurous character of art, its ever-present changes and novel creations" rendering it "impossible to ensure any set of defining properties" (1956, 32), while made in the course of his argument against the possibility of defining a work of art, seems, on reflection, to be at least as likely, if not more likely, to tell against the possibility of defining the artworld and the practice of art. It is the world and the practice, after all, not the (typical) work, that expands and changes.

What truly makes the antiessentialist objection moot is that neither (F′) nor (V′) is a definition. Still, though, that the artworld and the practice of art "expand" and "change" needs to be taken into account in defending any claim about what art's function is, especially if we take the present tense seriously, as we must in a claim of fact as opposed to logic such as (F′). Moreover, despite the fact that neither (F′) nor (V′) is an essentialist definition, there will be plenty of opportunities—some might say temptations—to define notions other than the notion of a work of art in essentialistic ways. So long as one

does not believe that Wittgensteinian "family resemblance" considerations militate against such proposals in general, however, one need not shrink from such tasks, but one will be well advised, when about to yield to such a temptation, to "look and see" whether it is reasonable in the instance in question to expect an extensionally adequate and philosophically enlightening definition.

Even as the antiessentialist objection is rendered moot, the intuition of a close relation between art and the aesthetic is honored by (F′), but it is important to notice that (F′) does not claim that each individual work of art distributively must enter into that relation. For the practice of art and the artworld to have an aesthetic function does not entail that each work of art must have an aesthetic function. Exactly what the relation is between that world and practice and individual works of art is something that needs to be discussed, but the antiaestheticist objection, with its Duchampian and Brechtian examples, shows that we can hardly take it as an unchallengeable intuition that the function of each work of art must be aesthetic.

The institutionalist objection, too, that, contrary to traditional aestheticism's definition (F), being a work of art depends on an institutionally conferred status, is not directly applicable to the new aestheticism's claim about the artworld and the practice of art, (F′). It is even reasonable to think that, to the extent that the new aestheticism emphasizes the practice of art and the institution of the artworld, it will naturally, if not inevitably, issue in some kind of institutional account of what a work of art is. If it does, the question to be faced then might well be whether this break with traditional aestheticism is enough to disqualify it from any claim to be a kind of aestheticism.

Explaining how the defender of (F′) can not only accommodate the intuition that the direct experience of a work of art is required for its understanding, appreciation, and assessment but also deal with the antipsychological and absent artist objections depends on clarification of the notion of aesthetic communication that I have introduced in (F′) and of what turns out to be its crucial constituent notion, appreciation, invoked in (V′). For a first approximation, I shall say that *aesthetic communication* consists in someone designing and making an artifact with the aim and effect that it be appreciated by someone

else. The psychology that must be defended as, first, nonbogus, and, second, sufficient to accommodate the intuitions concerning the necessity of the direct experience of art, is contained in the concept of appreciation. *Appreciation* is the new aestheticism's "aesthetic state of mind," and its central place in the account of aesthetic communication is the chief justification for calling it aesthetic communication, and thus for calling the theory connecting it with art a version of aestheticism.

In addition to a spectator's state of mind, of course, aesthetic communication involves somebody designing and making something and something designed and made, and it is in the course of describing this whole process that I hope to answer the absent artist objection—the objection that aestheticism has no adequate account of the contribution of the artist.

The intuition that some properties of works of art are artistically irrelevant, I have suggested, when combined with certain accounts of the aesthetic state of mind, can render aestheticism vulnerable to the antiformalist objection. One of my major tasks will be to give an account of appreciation that provides for this intuition without being vulnerable to the this objection. How it does this and whether it succeeds, of course, will depend on exactly how and where it draws the boundary between the artistically relevant and the artistically irrelevant.

The inference of the valuational thesis (V) from the functional definition of art (F) is, as we have seen, straightforward in traditional aestheticism, depending simply on an instantiation of the plausible principle that if something's nature consists in its having a certain function, then it is good as a thing having that nature just in case it can fulfill that function. Indeed, it might be more accurate to say that what I have described as the intuition of the inferability of the fundamental criterion of artistic value from the nature of art is not so much a prior intuition that traditional aestheticism honors as it is an elegant consequence of traditional aestheticism whose apparent intuitive acceptability derives from aestheticism rather than supporting it.

Be that as it may, a defense of any aestheticism worthy of the name, whether traditional or new, should show how the connection it

claims between art and the aesthetic supports the primacy of aesthetic criteria in the evaluation of works of art. Any inference with a premise about the function of the artworld and the practice of art (F') and a conclusion about the value of works of art (V') will, however, be much less obvious than traditional aestheticism's inference from (F) to (V). At least it will not be a simple matter of instantiating the principle just mentioned that takes one from a claim about the function of things of a kind to a criterion of value for things of that very kind, since (F') attributes a function to the artworld and practice of art, while (V') gives a principle of value for things of a different kind, works of art.

The Thesis Explained

With this overview of the prospects and problems of my project, the task of the next three chapters is to explain in detail thesis (F'), that the function of the artworld and the practice of art is to promote aesthetic communication.

Chapter 3 unpacks the crucial idea of aesthetic communication. The concepts of *designing, making, artifact,* and, especially, *appreciating* are central. Appreciating a state of affairs is explicated as one kind of finding value in experiencing it, in a broad, conceptually laden, *epistemic* sense of "experience" that has the consequence of extending the range of the experienceable, and hence of the aesthetic, well beyond the narrowly formal.

Chapter 4 explains how I understand the practice of art and the informal institution of the artworld associated with it—a practice and world that I understand as having arisen in Western Europe in the eighteenth century with the appearance of the modern conception of the fine arts. My claim is that what might be called *artistic communication*—an artist creating a work of art for an artistic audience— requires for its occurrence the existence of the practice of art and the informal institution of the artworld in a way that aesthetic communication does not. Accordingly, there is at least a conceptual distinction between an instance of *artistic* communication (this artist creating this painting and displaying it for this audience) and any *aes-*

thetic communication (this person designing and making this artifact to be appreciated by these people) with which it may be coextensive. Aesthetic communication, moreover, can occur independent of, and did occur long before the existence of, the artworld, artists, and works of art.

Chapter 5 discusses the idea of a function invoked in (F'). The relevant idea—what I call an *artifactual function*—is an extension of the idea of function used when we describe the function of an ordinary artifact (e.g., a knife blade). This idea of function is contrasted both with the *systemic* idea of function invoked when attributing functions to organs of living bodies and with that idea's close analogue, the anthropological idea of a *latent* function (often applied to the practice of art), in which a human society is in effect regarded as an organism. To understand (F') as employing the artifactual concept of function is thus to regard the practice of art and the artworld as themselves artifact-like in the sense in which the works of art central to them evidently are.

I do not attempt to analyze the artifactual notion of a function, but I propose and defend the following sufficient-condition claim,

(AF) If something is good at doing something that it was designed and made to do, then doing that is its (artifactual) function,

which is a fundamental premise for my argument for (F').

The Central Argument

Given this understanding of the artifactual idea of a function and this sufficient condition of its application, I argue in Chapter 6 for (F') by defending the view that the artworld and practice of art satisfies the antecedent of (AF)—that is, that promoting aesthetic communication is both (i) what the artworld and practice of art is good at doing and (ii) what its institutors designed and made it to do. The conjunction of (i) and (ii) with (AF) then entails (F'), that the function of the artworld and practice of art is to promote aesthetic communication.

I address the claim (i) that the (existing Western) artworld is good

at promoting the aesthetic by comparing its aesthetic capabilities with its capabilities in nonaesthetic activities (e.g., the promotion of religious beliefs or political programs) that it might be said to be good at and by comparing its aesthetic capabilities with the aesthetic capabilities of other, arguably nonartistic, practices and institutions (e.g., advertising or gardening and their worlds) that might be said to be good at promoting the aesthetic. I conclude that the artworld and practice of art is good at promoting aesthetic communication at least in that it is both better than any other world and practice at doing that and better at doing that than at doing anything else.

I address the claim (ii) that the artworld and practice of art was designed and made for aesthetic purposes by reflecting, first, on the views of Charles Batteux and those who followed him in articulating the conception of the "fine arts" basically as we now understand it, and, second, on the views of those promoting novel or marginal artistic practices as art (e.g., photography, cooking). I argue that in general these people have thought of the arts as unified by their aesthetic aims and that this fact entitles us to say that, for the purpose of applying (AF), art was designed and made to promote the aesthetic.

Consequences

The justification of (V')—the claim that aesthetic criteria are the criteria for evaluating works of art as works of art—by appeal to (F')'s claim about the aesthetic function of the artworld and the practice of art is the subject of Chapter 7. A principle capable of bridging this gap must, as I observed, be more complicated and controversial than any principle connecting the criterion of value for an artifact with its function that might be appealed to by traditional aestheticism. The crucial principle explained and defended, connecting the function of a practice and its world with a criterion of value for what participants in that practice (i.e., members of that world) do acting in their roles as participants in it, is:

> (FV') If an institution has a certain function, then something
> produced by someone acting in his or her role in that
> institution is good as a thing of the kind thus produced

to the extent that it has the capacity to contribute to
the function of that institution in the way appropriate
to it as a thing of that kind.

The Epilogue speculates on the future of the artworld and the prac-
tice of art in the light of the possibility that antiaesthetic impulses of
the sort now common among some members of the artworld might
cause the artworld and practice of art to abandon its aesthetic func-
tion.

Aesthetic Communication

A Paradigm of Aesthetic Communication

Consider someone designing and making an artifact with the aim and effect that someone else appreciates it—for example, someone polishing and carving a stone into a smooth spheroid incised with curving lines, then showing it to someone else, who finds it good to look at its graceful shape and decoration. I take this to be a paradigm of aesthetic communication. Such communication thus typically involves three elements: a designer and maker, an artifact made to be appreciated, and an appreciator. The substance of this chapter will consist mainly in explaining these three elements, but a few general comments are in order first.

In invoking the idea of communication I am conscious of following Leo Tolstoy, who notoriously claims that

> Art is a human activity consisting in this: that one man consciously by means of certain external signs, hands on to others feelings he has lived through, and that others are infected by those feelings and also experience them. (Quoted in Colin Lyas 1997, 61; Lyas gives a sym-

pathetic and helpful account of such currently unfashionable figures as Tolstoy and Benedetto Croce.)

I have no wish to defend anything like Tolstoy's account in detail, first because I am not at this point discussing art, but, beyond this, because I do not wish to restrict my account to feelings, nor, where feelings are in question, to feelings that the first person has "lived through" or feelings that "infect" the second person. What I want to take from Tolstoy is the idea of a *transaction* involving two people and something "external" that one produces for the other. This transaction, moreover, deserves to be called an instance of communication in that what is produced is designed to be—and, where it is successful, is—not just useful in some way or other but understood by the person to whom it is directed. What makes this communication worthy of being called *aesthetic* is that understanding the thing produced is not necessarily or characteristically a matter of—though it may involve—grasping some semantic content it embodies, but is rather a matter of *appreciating* it, in a sense that I explain in this chapter.

It is obvious that some elements in aesthetic communication can exist independent of others and, where they do coexist, can fail to be related in ways exemplified by the paradigm. Someone may make an artifact without designing it, or design and make it with neither the aim nor the effect that it be appreciated by anyone. (I may doodle idly; I may scratch a reminder to myself to buy orange juice at the grocery store on the way home on a Post-it note and stick it on my computer monitor; I may design and make a substitute for a broken sofa leg with the hope and expectation that no one will ever see how crude it is.) Doubtless many things made are not designed and many things designed are not designed to be appreciated. Something made with the aim that someone else appreciates it may not have any such effect, either because it is never shown to anyone or because, having been shown to someone, it fails to afford appreciation. Someone may appreciate things that were not made to be appreciated (an ancient coin, perhaps, or a plumbing appliance), and someone may appreciate something made without being designed (a random doodle) or something that was not made at all (a waterfall).

I do not think that much would be gained by wondering how fully the paradigm must be approximated by an occurrence for it to count as a case of aesthetic communication: How would one decide? (Must there be a maker? A designer? An appreciator?) Suppose that all the "places" in the paradigm—the designer and maker, the artifact, the appreciator—are filled and that all the paradigmatic relations—the artifact designed and made by the maker with the aim and the effect that it be appreciated—obtain. How may the places be filled and the relations made to obtain? (Must different people fill the roles of maker and appreciator? May the designer and the maker be different people? Must there be just one maker? How about a partnership? A committee? A corporation? Must the maker do something, as contrasted with letting something happen? Must the artifact be a physical thing? Must the aim be that living humans appreciate the thing? How about a dead Chinese emperor, or God?)

The utility of appealing to the idea of a paradigm in this connection is to permit us a certain insouciance in the face of such questions. Rather than fretting over what must inevitably be somewhat arbitrary decisions about borderline cases, we are encouraged to focus on various ways in which occurrences can approximate or instantiate it, with the aim of seeing what the consequences of such variations may be for various claims we may wish to make about the aesthetic and its relation to the artworld and the practice of art.

The Centrality of the Concept of Appreciation

It seems appropriate nonetheless, to propose (perhaps to legislate) a certain kind of necessary condition, not as part of an ambitiously or even interestingly essentialist account of the aesthetic but to make it easier to see how the view that will eventually emerge is legitimately describable as a kind of aestheticism. The condition is that the concept of appreciation must enter into the characterization of any state of affairs that is to have aesthetic status of any kind. That is to say, for it to be worthwhile even asking to what extent a state of affairs approaches the paradigm of aesthetic communication, that state of af-

fairs must include either someone who at least tries to design and/or make an artifact to be appreciated, or a thing that at least has the capacity to be appreciated, or someone who at least sets out to appreciate something. A state of affairs that perhaps barely satisfies just one of these disjuncts (e.g., someone thinking of making an artifact that someone might appreciate, a remote unvisited natural scene that would perhaps be appreciated if the right person were to see it, someone thinking of going to a museum) is far from a paradigm of aesthetic communication, but it is, so to speak, on the scale. There's at least *something* aesthetic about it.

On the other hand, someone designing and making an artifact to be understood by someone else but with no thought of its being appreciated, an artifact whose capacity to afford appreciation is vanishingly small, or an artifact that someone else sees and understands without appreciating (e.g., someone scribbling a list and handing it to someone else who uses it to buy groceries), though it shares the structural features of our paradigm of aesthetic communication insofar as both are instances of communication, is not, I shall say, aesthetic in any way. The *aesthetic* character of a state of affairs consists in its connection with appreciation; appreciation, one might say, is the new aestheticism's aesthetic state of mind. Accordingly, the account of appreciation to which I now turn is crucial to my project.

Two Constraints on the Account of Appreciation

I want to stress that, although I take "appreciation" to be central to my account of the aesthetic, I do not, by "appreciation," mean "aesthetic appreciation." That is to say (to express the matter somewhat less paradoxically), I do not propose to give an account of the genus appreciation and then describe a species of appreciation that is aesthetic. Rather I hope to give an account of appreciation *simpliciter* to deploy in my account of aesthetic communication. I will be happy to call this "aesthetic appreciation," as long as it is clear that my aim is to break into "aesthetic space" via the concept of appreciation simpliciter rather than to invoke a prior understanding of the concept of the aesthetic in

understanding what kind of appreciation aesthetic appreciation is. Only thus will thesis (F'), that the function of the artworld and the practice of art is to promote aesthetic communication, be fit to serve as the fundamental thesis of a kind of aestheticism once the concept of aesthetic communication is suitably unpacked. If some such "reductive" move is not incorporated at some point (and I am fully aware that the history of philosophy is littered with the wreckage of various reductive projects), the aestheticism I want to defend would stand accused of invoking the idea of the aesthetic in its most important and characteristic thesis without ever saying what the aesthetic is.

Given that thesis (F') is a factual claim, it is equally important that the idea of appreciation—the central concept in characterizing what art, according to (F'), functions to promote—not require explanation in terms of the concept of art, for on this view it must be a contingent matter that art does what it does. If the concept of art were to enter essentially into our account of aesthetic communication, it would be nonsense to suppose, as (F') does, that aesthetic communication could occur prior to or independent of art. If our account of aesthetic communication (via our account of appreciation) were in effect to be given in terms of some transaction or state of mind characteristic of our intercourse with works of art, then (F'), though perhaps true, would be uninteresting.

This limitation does not, however, rule out the invocation of examples of aesthetic communication from the arts even at this stage, where the idea of aesthetic communication is being initially explained. In doing this we will not thereby render our account of the aesthetic dependent on a prior understanding of the concept of art, nor do we beg any questions about the centrality of the aesthetic to art. (Surely all but the most extreme antiaestheticist would be willing to admit that art is at least sometimes aesthetic.)

To flesh out the characterization of aesthetic communication without appealing to the concept of art or to any prior concept of the aesthetic is the aim of this chapter. A paradigm of aesthetic communication consists in someone's designing and making something to be appreciated that is appreciated by someone else. I turn first to the fundamental concept of appreciation.

Appreciation Defined

> Appreciation is finding the experiencing of a state of affairs to be valuable in itself.

There are, of course, different uses of the notion of appreciation that I do not address—as, for instance, in "I appreciate all you've done for me" or "I appreciate the difficulty you're in," or "The value of most stocks appreciated during the late 1990s." Though the first two of these are arguably related to the notion of appreciation I am attempting to capture, in that the first seems to involve a finding of value, while the second seems to suggest a common (at least vicarious) experience, I do not think that it is a merely ad hoc maneuver to consign all of them to different senses of appreciation. (I first proposed a version of this account of appreciation in Iseminger 1981; further discussion appears in Iseminger 2004.)

A preliminary formal point is that what is appreciated, in the relevant sense, is a state of affairs—something's having a property—rather than a thing or property. In the first instance someone appreciates a spheroid's being graceful (the gracefulness of the spheroid, that the spheroid is graceful) rather than the spheroid or gracefulness simpliciter (though no doubt one could work out derivative ideas of what it is to appreciate a thing or a property).

The task now is to explain how I understand the concept of experience and the concept of finding something valuable in itself.

Experiencing

Experiencing a state of affairs is a matter of having direct (noninferential but not necessarily infallible) knowledge that that state of affairs obtains. The concept of experience I am invoking, then, is an *epistemic* one—a certain kind of knowledge—rather than a *phenomenological* one—a concept of something that seems a certain way to its subject. It is related to the concept we employ when we say that hearing rather than seeing is the mode of experience whereby bats chiefly locate themselves relative to surrounding objects, as contrasted with the one we employ when, with Thomas Nagel (1974), we

wonder what a bat's experience must be like. Seeing that the spheroid is graceful is, then, an instance of experiencing the spheroid's being graceful in the relevant sense. Experiencing thus may (but need not) be a sensory matter. (One can, for example, feel the tension between two metaphors in a line of poetry or get a joke.)

Merely knowing that a spheroid is graceful, say, on the basis of testimony, however reliable, is not sufficient for experiencing, and hence for appreciating, that state of affairs. (I am not denying that one can know that a spheroid is graceful on the basis of testimony.)

On the other hand, experiencing a state of affairs, even where it is sensory (i.e., where it is an instance of seeing, hearing, touching, smelling, tasting) is not merely sensory. It typically involves conceptual capacities and may depend on prior knowledge. One can see or hear that the water is boiling on the stove and not merely infer that it is boiling (as one would, for instance, from seeing the position of the hands of a clock or hearing the buzz of the timer one had set to go off at the appropriate time.) But this requires that one have concepts like *water* and *boil*, and it is facilitated, if not made possible, by prior knowledge that, for example, one recently put some water in the saucepan and turned on the burner.

Accordingly, one could be wrong. One could think that one saw that the water was boiling on the stove (and hence that one had experienced it) when it wasn't. But then one didn't really see (experience) water boiling on the stove. That is to say, I think of experience (seeing, hearing, etc.) as a way of knowing in the full-blooded sense in which knowing that something is the case requires that it be the case. In this respect experiencing is to seeming to experience as knowing is to believing. Experiencing a state of affairs involves getting it right. Accordingly, if experiencing some such state of affairs as a spheroid's being graceful is to be part of appreciating it and hence of aesthetic communication involving it, it must be possible to be right (or wrong) in some sense about whether or not the spheroid is graceful.

I am inclined to respond to this requirement by adopting a realist view of such state of affairs as a spheroid's being graceful, but I shall not defend aesthetic realism in this book. My justification for this evasion is that even an antirealist about such a state of affairs typically invokes a distinction between, say, a correct and an incorrect

grasp of it, despite not necessarily agreeing that a correct grasp must be of the truth about it or that grasping the truth about it necessarily involves grasping a real property of it. (See, for example, Roger Scruton 1974.)

Furthermore, so long as antirealist theories of truth (see, for example, Hilary Putnam 1981) are a viable option (if, indeed, they are), an epistemic conception of experiencing a state of affairs that requires that one must somehow "get it right" for it to count as genuinely experiencing the state of affairs in question can even explain getting it right in terms of truth without being committed to realism about the states of affairs that are the objects of such experience. On either view, one can (correctly) see that the spheroid is graceful without its grace necessarily being a real property of it. Accordingly, though I shall continue to speak with the realists, I shall do so without commitment and, hence, without guilt.

Finding Something Valuable in Itself

Finding something valuable, as opposed to merely liking it, requires that one have the thought that it is good, a thought that makes a claim on other people. If I find value in something, I am committed to at least being disposed to recommend it to others and obliged to be in a position to back up any such recommendation I may make. To respond to a challenge to my finding of value with a shrug and the remark, "Well anyway *I* thought it was good," is to give up the claim of value, while a similar shrug and the remark, "Well anyway I liked it," is a reassertion rather than a withdrawal of an expression of preference.

Finding something valuable *in itself* is, of course, to be contrasted with finding something *instrumentally* valuable—good as a means to something else. (See Christine Korsgaard 1983 for helpful reflections on the distinction between valuing something in itself and valuing something instrumentally.) Typically people value money, for example, instrumentally; they value it for what they can do with it, namely purchase things that they need or want, or provide for their children's education or their own retirement, or support causes in which they

believe. Some people may well find money valuable in itself (though many would regard someone who valued money in that way as exhibiting an unappealing character trait, if not a moral defect.)

Finding value, as contrasted with experiencing, as I have explained it, is not an epistemic concept (nor is it a phenomenological one), but only a *doxastic* one—a concept of a certain kind of belief, which may or may not be true. One may, in this sense, find something valuable, in itself or instrumentally (or both), without its being valuable.

Finding Experiencing Valuable in Itself

There is a tradition in the theory of value that holds that ultimately the only thing that one ought to value in itself is experience, in some sense of that term. Why ought we to value even the things we purchase, it might be asked, if not because they will be instrumental to worthwhile experiences, either our own or others'?

(Someone who held that only experiences were ultimately valuable in themselves might still want to distinguish between the kind of value present in that which itself affords valuable experience—a natural scene or a painting, perhaps—and the kind of value present in that which enables us to afford the experience—the money to travel to a national park or to buy a painting or at least to visit a museum. Compare, for instance, C. I. Lewis's conception of *inherent* value in Lewis 1946.)

I do not here commit myself to any view about the primacy of experiences in general as valuable in themselves, but I do claim that appreciating something is a matter of valuing in itself (in my doxastic sense of valuing) the experience (in my epistemic sense of experience) of which it has the capacity to be an "object"—that is, the experience it affords. Appreciating a state of affairs, as valuing in itself an experience one has or has had of it, thus has the structure of a belief about the value of coming to know that state of affairs in a particular way. One may appreciate a state of affairs that is unworthy of appreciation, but one cannot even do that if one is wrong about what the state of affairs is.

Note that one might well value something without appreciating it.

One might, for instance, value a bank note, instrumentally or in itself, without valuing the experience it affords (as contrasted with the experience it might enable us to afford). That is, one might think that having a $10 bill was good because of what one can purchase with it, or one might think that having a $10 bill was good in itself, without finding the contemplation of the just-slightly-off-center positioning of Alexander Hamilton's portrait on the new $10 bill valuable in itself. One might in fact do all three, but if one does only one or both of the first two one is not appreciating the $10 bill.

Conversely, one might appreciate something without valuing it except as a source of valued experience. Edward Bullough (1912, 758–59) famously imagines finding value in experiencing a fog at sea, apparently without finding anything else good to say about that dangerous and in many ways unpleasant phenomenon.

Experience Valued in Itself and Enjoyment

When we value experiencing a state of affairs in itself, do we necessarily enjoy doing so as well?

No doubt often we do, but not, I think, invariably. There are, first of all, clear cases of experiences we value but do not enjoy. We go to a performance by a band we have heard of, are perhaps dubious about, but know that we should hear. We don't enjoy the experience, but value it, because we are now, as we were not before having it, in a position to decide on good grounds not to repeat it. It was a "learning experience," as the saying goes.

Our valuing of such experiences, however, seems not to be a case of valuing it in itself. Still, there appear to be counterexamples that cannot be readily dismissed even to the thesis that experiences valued in themselves must be enjoyable ones. Consider watching the final scene of *Hamlet* or the conclusion of Alban Berg's opera *Wozzeck*. Someone may value the experience those works afford and not just for what she might learn from them; she may, for example, attend performances of them at every opportunity. She might take pleasure in these scenes or enjoy them, but that would hardly be typical of a discerning and attentive member of an audience at either of them.

(Something like the possibility of valuing in itself an experience that one doesn't enjoy is perhaps being exploited, no doubt ironically, by the irritated-looking man in a *New Yorker* cartoon saying to his equally irritated-looking wife as they leave a theater, "I never said it wasn't good. I merely said I hated it.")

When we enjoy experiencing a state of affairs, must we find that experience valuable in itself as well? Not necessarily: One can enjoy experience in the phenomenological sense of experience—how it feels—without experiencing anything in my cognitive sense of "experience" or even having the capacity to find anything valuable in my doxastic sense of "find value." Arguably, some animals and young children who lack the concept of good or the concept of a breeze enjoy the feeling of a cool breeze on a hot day.

Not only that, people who have these conceptual capacities may well enjoy experiences (in either the phenomenological or the epistemic sense) that they do not find valuable. (Perhaps this is because they regard them as somehow tawdry or unworthy or at best trivial.) It is perhaps equally clear that one may enjoy experiencing a state of affairs in the full epistemic sense—savoring the details of an erotic picture, for example—without finding the experiencing of those details to be valuable. (It is no news that there may be a conflict between Pleasure and The Good.) And even if someone does value the experience of savoring those details, he would typically value it as instrumental (to sexual arousal) rather than in itself.

Meeting the Antipsychological Objection

If appreciation is the new aestheticism's aesthetic state of mind, we are now in a position to say something about how the new aestheticism might respond to the antipsychological objection.

Appreciation, as I have described it, is a complex phenomenon, some aspects of which are "mental" and some aspects of which are not. Partly this is due to the epistemic character of the experience that is one of its components. In the same way that it is a (typically) nonmental truth condition of someone's knowing that something is the case that it be the case, it is a (typically) nonmental truth condition

of someone's experiencing (and, hence, of someone's appreciating) a state of affairs that that state of affairs obtain. Another part of the complexity, of course, is that there is another mental aspect of appreciation, the finding of value. And finally, it is the experience rather than its object that is found to be valuable (in itself).

The first part of the antipsychological objection, it will be recalled, is that aestheticism appeals to bogus acts or states of mind. The question for the new aestheticism, then, is whether experiencing (in the sense specified) and finding value are mental activities we engage in and, if so, whether in particular we ever find experiencing valuable in itself. Do we ever think that, for example, seeing the gracefulness of a stone is good in itself?

It seems clear that we do, and the strongest case for thinking that the present account of appreciation will withstand at least this part of the antipsychological objection is that it is in effect borrowed, with one substitution and one addition, from the philosopher who has most prominently advanced that objection, George Dickie. Recall that Dickie defines a work of art in part in terms of the notion of appreciation, more specifically, the notion of being a candidate for appreciation. In explaining that definition, he in effect summarizes what I have called the antipsychological objection, emphasizing that

> there is no reason to think that there is a special kind of aesthetic consciousness, attention, or perception, . . . [nor] any reason to think that there is a special kind of aesthetic appreciation. (Dickie 1974, 40)

Rather, he says,

> All that is meant by "appreciation" in the definition is something like "in experiencing the qualities of a thing one finds them worthy or valuable." (Dickie 1974, 40–41)

The offhandedness of the phrase "something like" and the fact that, so far as I am aware, Dickie has had virtually nothing else to say about the concept of appreciation make it difficult to be certain that his concepts of finding value and of experiencing would turn out on careful examination to be essentially the same as mine, but all signs point

that way. One of the few further remarks he makes, for example, distinguishes appreciating from enjoying (Dickie 1974, 108). Presumably the words "finds . . . worthy or valuable" are deliberately chosen at least in part to mark some such distinction as that between valuings, on the one hand, and pleasures or enjoyments, on the other. The phrase "experiencing the qualities of a thing" seems quite explicitly to emphasize both the structure of the object of experience as a state of affairs and the cognitive nature of experience, though the thing rather than the state of affairs is the "official" object of appreciation.

If I am right about these matters, Dickie's account of appreciation can be turned into something tantamount to my account simply by replacing "them" by "it" and inserting "in itself" at the end, thus: In experiencing the qualities of a thing one finds it (i.e., the experience) worthy or valuable in itself. The result seems not to differ materially from my claim that appreciation is finding the experiencing of a state of affairs to be valuable in itself.

There are, of course, substantive differences between the account just given and Dickie's account. In making one of the constituent mental states (the experiencing) itself the object of the other (the valuing), rather than treating the object of the experiencing (the thing or the thing as having certain qualities) as also the object of the valuing, the new account supports the claim lately made that (in the typical case) one's valuing a $10 bill is not an instance of appreciating it, in a way that Dickie's does not. Once this change is made, the idea of valuing in itself, as contrasted with valuing instrumentally, not invoked by Dickie, has the effect of ruling out "learning experiences" as cases of appreciating the states of affairs thus experienced. Neither of these changes, however, involves smuggling concepts of novel or suspect mental states into my account of appreciation that are not already in Dickie's.

The ultimate strategy of the antipsychological objection, of course, is to argue that, without invoking some bogus psychology or other, the putatively "aesthetic" state of mind will not support interesting claims about the relation between art and the aesthetic. Whether thesis (F'), that the function of the artworld and the practice of art is to promote aesthetic communication, turns out to be both interesting and well supported is something that the reader will have to decide

when the argument for it is completed, but suspicions of bogus psychology should not stand in the way of its acceptance.

Meeting the Antiessentialist Objection

I have offered no essentialist definition of the concept of a work of art, and I tiptoed around the question of whether I was proposing an essentialist definition (or at least an important necessary condition) of the concept of aesthetic communication. But I have undoubtedly offered an essentialist account of appreciation. Not to be coy about it, the definition in all of its formal glory would go something like this:

> *Def:* S appreciates x's being F if and only if S finds
> experiencing x's being F to be valuable in itself.

We must "look and see" whether this account can withstand antiessentialist scrutiny.

Recall Marshall Cohen's objection to the claim that the appropriate way to experience something aesthetically is to contemplate it. On the contrary, he says,

> If one ought to contemplate a Redon or a Rothko, one ought to scrutinize the Westminster psalter, survey a Tiepolo ceiling, regard a Watteau, and peer at a scene of Breughel. (1962, 490–91)

Considerations of this sort are sufficient to undercut the idea that aesthetic experience is essentially contemplative (while, of course, supporting the idea that it at least sometimes is), but the defender of a specifically aesthetic state of mind is unlikely to let the matter rest there. No doubt to identify that state of mind with contemplation is to fall victim to what Wittgenstein would call a "one-sided diet of examples," to make "the negligent assumption that the rapt Oriental contemplating a Chinese vase is the paradigm of aesthetic experience," as Cohen says (1962, 491). Someone with essentialist leanings would, however, be bound to remark that contemplation and the various activities Cohen distinguished from it and from one another are all different ways of doing one kind of thing—coming to know prop-

erties of these objects by looking at them, or, equivalently, visually experiencing states of affairs of which those objects are constituents. Why can we not incorporate this state of mind—experiencing (in the epistemic sense)—into our account of the aesthetic state of mind, appreciation?

One can anticipate a Wittgensteinian rejoinder. In the course of his demolition of the idea that every word signifies, Wittgenstein asks us to consider an analogous situation:

> Think of the tools in a tool-box: there is a hammer, pliers, a saw, a screw-driver, a rule, a glue-pot, glue, nails, and screws.—The functions of words are as diverse as the functions of these objects. (1953, §11)

Wittgenstein then proposes and criticizes an essentialist response:

> Imagine someone's saying: "*All* tools serve to modify something. Thus the hammer modifies the position of the nail, the saw the shape of the board, and so on."—And what is modified by the rule, the glue-pot, the nails?—"Our knowledge of a thing's length, the temperature of the glue, and the solidity of the box."—Would anything be gained by this assimilation of expressions? (1953, §14)

The question is, of course, purely rhetorical.

One can then imagine the same sort of question being asked concerning our epistemic concept of experience. Is anything to be gained by assimilating contemplating, scrutinizing, surveying, regarding, and peering to one another as ways of *seeing* that certain states of affairs obtain—not to mention assimilating seeing to hearing, tasting, etc., as ways of sensing and assimilating sensing and understanding (e.g., in the sense of understanding a joke) to one another as ways of experiencing?

This question is not merely rhetorical. There seems to be a greater initial plausibility to at least the first two assimilations than to the assimilation of sawing and measuring to one another as ways of modifying something; the concepts of seeing and sensing are familiar and seem readily understandable as concepts of genera whose species are, respectively, contemplating, scrutinizing, etc. and seeing, hearing, etc. Perhaps the same cannot be said for the assimilation of getting a

joke to seeing, hearing, and the like, but in all these cases what one hopes to gain is an understanding of unobvious but theoretically enlightening generalizations beneath apparent diversity. Whether something like this is gained by the sorts of essentialist "assimilations" made in this book is something that the reader will have to decide after reading it.

Designing and Making Artifacts

A paradigm of designing and making is a case where someone formulates a plan and, acting in accordance with that plan, intentionally brings something into existence and endows it with certain properties. In our paradigm of aesthetic communication, we may imagine, someone thought of a way of turning a stone into a decorated spheroid and, acting in accordance with that plan, intentionally shaped the stone into a spheroid and then incised decorations on it. The product of a paradigm case of designing and making—the shaped and decorated stone spheroid—is a paradigm of an *artifact*. (For some reflections on the concept of an artifact, see Iseminger 1973.)

There are many ways in which designing and making can approach or deviate more or less from this paradigm, quite apart from the fact that in many situations the designer and the maker are different people—architects and couturiers design, carpenters and tailors make.

Designing may paradigmatically be a process that anticipates making and does so in detail, but it often aims at general results (as, for example, making a "head" arrangement of a jazz standard), and it may be essentially contemporaneous with making (as, for example, the designing of an improvised jazz solo or an "action" painting). Something like design may even be retrospective, as when a photographer produces dozens of images in an experimental spirit and selects from among them. Designing can be independent of any actual or even intended making, as in some kinds of architectural competitions.

Making is paradigmatically a process of intentionally bringing something into existence, but it is possible intentionally to endow something with new properties without causing it to be a different kind of thing, as one may paint a white house yellow. It would be odd

to say that any (new) thing is made in such a process, but it is not always clear where to draw the line between making some (new) thing and modifying something already in existence; in any case, it is often equally unclear that the distinction is significant. Conversely, it is evidently possible to make something into a different kind of thing without intentionally endowing it with any particular new properties, as one may display a gracefully shaped piece of driftwood unaltered in such a way as to turn it into a sculpture. (Even further away from the paradigm, a John Cage may make ambient sounds during a period of silence or sounds produced by randomly tuned and played radios into a piece of music without even intentionally selecting any of their characteristics.)

As these last examples suggest, even though making an artifact may paradigmatically involve "working" on some kind of material, it may shade off into displaying, even as designing may shade off into selecting. Furthermore, it is important to remember that artifacts are not necessarily physical, or, if physical, necessarily physical objects. Arrangements of words, conceived not as mere physical marks on paper, or of sounds, not physical objects but (perhaps) physical events, can apparently be designed and made as well. (A Platonist might be inclined to say that these are rather examples of cases where designing and making shade off into selecting and displaying; quite apart from this, it is not clear what would constitute making or displaying as something more than designing or selecting in such cases, unless it were performing—reading a poem aloud or playing a piece. Even here most people can "perform" poems silently for themselves, and some can do the same with pieces of music. The idea of making is clearly being stretched to the limit here, and perhaps beyond it.)

If the typical result of designing and making is called an artifact, then that idea will, of course, be stretchable as far as and in the same ways as the concepts of designing and making. There is, therefore, no straightforward and unequivocal answer to the question "Is this an artifact?" Artifactuality is "relative to a description," as the saying goes. An object might be artifactual as incised, but not, say, as quartzite. The question whether something is an artifact thus gives way under analysis to the more precise question whether a state of affairs obtains artifactually.

One result of observing this usage is a convenient fit in the account of aesthetic communication between the intermediary "external object"—now conceived from the point of view of its designer and maker as a state of affairs rather than a thing—and appreciation, whose object is already conceived of in this way.

Taking account, then, of our recent accounts of appreciation and of designing and making artifacts, an expanded and more detailed account of the structure of a paradigm of aesthetic communication—originally someone designing and making an artifact with the aim and effect that it be appreciated by someone else—goes like this:

> Someone formulating a plan and by acting in accordance with that plan intentionally bringing about a state of affairs with the aim and effect that someone else find experiencing that state of affairs to be valuable in itself.

It will do no harm to continue to speak of some thing's being an artifact or of some thing's being appreciated—perhaps we could understand such locutions in terms of some function of the number, proportion, importance for certain purposes, etc., of the thing's properties that it has artifactually or that are appreciated. It would still be the case, nevertheless, that those locutions would ultimately be explicable in terms of designing and making or of appreciating states of affairs

"Artifact" thus used as a noun is of interest to philosophers of art chiefly because it is (almost) universally accepted among them that a thing's being an artifact is a necessary condition of its being a work of art. Since my project does not involve offering a set of necessary and sufficient conditions for being a work of art, I will not pursue this matter further here.

Artifacts Designed and Made to Be Appreciated

Someone who designs and makes an artifact with the aim that it be appreciated will naturally observe certain constraints that arise from this aim and from the nature of appreciation.

Most fundamentally, what is to be appreciated must be capable of

being experienced. This is certainly a minimal constraint, but it is not negligible. Many states of affairs are such that we cannot experience them; accordingly, we may design and make states of affairs that are beyond appreciation. A painter might quite consciously produce a painting while working on it only on Sundays and thus be responsible for the coming into existence of the state of affairs of the painting's having been worked on only on Sundays. But we could not see (hear, etc.) that this state of affairs obtained, and, hence, we could not appreciate it.

We could certainly read a sentence, say, on the back of the painting ("This painting was worked on only on Sundays") or as a title (*Sunday Painting #3*), grasp the proposition that the painting was worked on only on Sundays and even come to know that that proposition was true. And it might turn out that knowing that a painting was worked on only on a Sunday would help us to see (experience) and thus to appreciate some other state of affairs involving the painting, say, its deliberate naiveté (as if by a "Sunday painter") or its being a critique of conventional religious observance (as if to say that this is a better thing to be doing than going to church.) But none of these things separately nor all of them together amount to seeing that the painting was painted only on Sundays, not even in the conceptually loaded, epistemic sense of "see" in which we can see that a painting is anguished or is a portrait of a screaming pope.

Many artifacts produced with no thought of appreciation can, of course, be seen (e.g., a grocery list), but are typically unlikely (pace John Cage) to afford appreciation. Accordingly, someone who makes something with the aim that it be appreciated must have some sense of who, if anyone, is likely to approach what he or she is making with the thought of appreciating it and of what such people are likely to appreciate, if he or she is to achieve the effect that it is appreciated.

What Can Be Appreciated

More generally, what sort of things can be appreciated? First, though an artifact is a part of my paradigm of aesthetic communication, there is no presumption that only artifacts can be appreciated.

It is obvious that natural objects, undesigned and unworked, even unarranged, unframed, and unselected, can afford appreciation in the sense I have described.

Furthermore, although my paradigm of aesthetic communication certainly involves the appreciation of a physical object (as having certain properties or entering into certain states of affairs), there is no necessity that appreciation be thus limited. The question is what else, if anything, beyond physical objects as entering into states of affairs is experienceable in the epistemic sense and hence at least not debarred a priori from having the capacity to be appreciated.

It is clear, for one thing, that we can see, hear, etc., not only states of affairs, in the sense of things instantiating properties at a time, but *events* or *processes*, states of affairs followed by other states of affairs in time—a person's uttering a sentence, singing a tune, or moving from one place to another, a sound's becoming louder and then dying away, an avalanche's rumbling down a mountain. So we can experience not only physical states of affairs but physical events or processes.

Of course, not every physical thing, event, or process is available to be experienced and hence appreciated. Some are too big (the cosmos) or too small (neutrinos) for anyone to see, hear, etc.; some are not in the right place at the right time (the Eiffel Tower, the Battle of Gettysburg, the 2005 Super Bowl) to be experienced by people who as a contingent matter of fact are, say, in Northfield, Minnesota, on June 29, 2003.

Moreover, in addition to the experience of middle-sized physical things, events, or processes, I have been assuming that there is what might be called *semantic* experience. We directly grasp what speakers, utterances, and sentences mean. We typically do this by hearing what is said or seeing what is written, but this is, of course, not sufficient for understanding. Conversely, the absence of a spoken utterance or a written sentence does not prevent us from having this kind of direct grasp of meaning. I may remember an utterance or a sentence that I am no longer seeing or hearing and grasp what was meant in a way that I did not when I was seeing the sentence or hearing the utterance.

Grasping the fact that a proof works, noticing that a remark is

funny, feeling the suspense in a well-plotted story, recognizing that the metaphors in a poem cohere and reinforce one another—these seem to exemplify experience in the epistemic sense just as clearly as do seeing that a stone is graceful or that water is boiling. That is, they are instances of noninferential knowledge—true, but not necessarily in principle infallible—of what are in this case fundamentally semantic states of affairs. In order to have such an experience, it is not sufficient merely to know that such states of affairs obtain—to have understood an explanation of the successes of the proof, the joke, the story, or the poem. One must "get" it (and, of course, it must be there to be got—the proof must really be valid, the joke really funny, the story really suspenseful, the imagery really coherent).

It is, therefore, at least conceivable that any such state of affairs could be appreciated; that is, that someone could find the grasping of it to be valuable in itself. It is, moreover, obvious that many such states of affairs are in fact appreciated, witness the behavior of those who regularly reread (perhaps even only in memory) favorite poems.

I do not think there is anything inherently mysterious about our capacity to grasp meanings. That it is a nonsensory analogue of seeing is, I take it, a fundamental insight of Platonism. I suspect, or at least hope, that there are viable alternatives to Plato's way of making sense of this capacity, but if it should turn out that there are not, that would be the best possible argument for Platonism. My only concern here is to insist on the analogy itself. Even Wittgenstein, while denying that understanding is an experience, did not deny that there are experiences of understanding.

The mention of poems existing in memory raises a final point. Conceivably I could produce a poem, remember it, return to it, and appreciate it without making a mark or producing a sound. But for a paradigmatic aesthetic communication to take place, in which someone makes something for someone else to appreciate, what is made cannot (barring the possibility of mind reading) have a purely mental existence; it must be a public object—an "external sign," as Tolstoy would have it—in the sense that it is in principle experienceable by anyone with the appropriate background (e.g., knowledge of the style of the piece or the language of the poem).

Applying the Concept of Aesthetic Communication

I conclude this chapter with some cases. I first work though a few unobvious and perhaps controversial cases to show how the concept of aesthetic communication as here explicated works out in practice, after which I append some cases on which the reader may sharpen his or her understanding of the idea and of its central concept, appreciation. Here are some things to keep in mind while reflecting on these cases.

Though many of them evidently come from the arts, some do not. The current question, however, is not whether or not they are examples of art. That question would be premature, since I have as yet said virtually nothing about art, except that aesthetic communication (as well as appreciation not involving aesthetic communication) is possible prior to and independent of art, a point that some of the cases serve to illustrate. The current question, rather, is whether and to what extent they are examples of aesthetic communication as I have explained it. Perhaps the basic issue, then, is whether they involve appreciation—actual, intended, or potential.

It will be necessary for the reader to fill out the stories a bit in some cases in order to get intentions into the picture. Remember, though, that it is perfectly possible to have many intentions at once and, specifically, to intend that something one is designing and making do more than one thing. Intending is not the sort of mental state that takes up mental space that other mental states are thereby prevented from occupying, as fretting about the size of the audience prevents one from enjoying the play. Intending that something be appreciated does not entail only intending that it be appreciated nor does it entail intending that it only be appreciated. (One might exemplify either or both of these latter states of mind at the same time as one intended something to be appreciated, of course; but it is not a necessary consequence of intending that something be appreciated that one exemplify either of them.) Intending that a painting have a political impact or a religious function does not rule out intending that it be appreciated; one might well intend that it be appreciated in order that it might have a political impact or a religious function. (Nor does its actually having a political impact or a religious function rule out its

actually being appreciated or its having the capacity to afford appreciation.)

By the same token, appreciating something is not in general incompatible with other attitudes one might take toward it. One might not be able to appreciate a fog at sea if one was frantically trying to keep from hitting an iceberg looming in front of one, but one could appreciate it while keeping a careful lookout for icebergs.

Supposing that there is at least some degree of intended, actual, or potential appreciation (the finding of value ranging anywhere from "OK, I guess" to "Fabulous!"), the next task is to see how, if at all, other elements of aesthetic communication might be involved. (Again, feel free to fill out or alter any of these stories to raise an issue or to clarify a point.) Remember that some slots in the structure of the paradigm—a maker, an artifact, an intended, actual, or potential appreciator—may not be occupied, and, if they are, they may be occupied in a variety of ways. The maker may be a partnership (perhaps of people who lived centuries apart, as in an orchestral fugue by Bach-Stokowski, as a concert program might say), a group, a committee, a corporation, etc. Remember that making can shade off into overseeing, arranging, touching up, repairing, selecting, framing, etc., and that not just physical but semantic states of affairs—arrangements of words with meanings—can be made to be appreciated, as can any appropriately public event or process. Remember also that the intended appreciator might be the maker herself, her patron, her peers, her ancestors, God, posterity, or whoever will pay to hear or see it, and that actual and potential appreciators might be from a time and culture distinct from that of the intended appreciators (if indeed there were any).

As I suggested, there seems to be little point in trying to decide in the abstract how closely something must approximate the paradigm to count as an instance of aesthetic communication. For specific purposes and in particular circumstances, however, it may well turn out to matter whether, for example, an individual or a team made something, the thing made is durable (a statue) or ephemeral (a fireworks display), the intended appreciators were intimate friends or a stadium full of paying customers, and so on.

So far I have suggested only that the following cases be used to clar-

ify the idea of aesthetic communication as I have explicated it. It would be natural to want to use them as well to test whether that explication is any good. Does my explication cut nature at the joints, so that all and only genuine instances of aesthetic communication are seen to be so by its criteria? Or rather (taking account of antiessentialist doubts) does it focus on an appropriate paradigm and sketch in the blurred boundaries beyond which lies the nonaesthetic in something like the right places and in something like the right dimensions?

This question presupposes, I think, firmer and more detailed intuitions about the boundaries between the aesthetic and the nonaesthetic than most of us have. Certainly some results would be immediately suspect. If an account of appreciation were to imply that someone reading a newspaper only to find out what the temperature was going to be was appreciating it, or an account of aesthetic communication were to imply that someone setting a live trap only to rid her yard of woodchucks was attempting to communicate aesthetically with the woodchucks, then so much the worse for those accounts.

Indeed, some of the cases below that would evidently qualify as examples of aesthetic communication on the current view would almost certainly not be regarded as paradigms of the aesthetic by everyone, to the extent that some might resist their seriously being so classified. Undoubtedly the current view casts a wide net, both in the range of things it takes to be appropriate objects of the experience that is part of aesthetic communication (not just sights and sounds but tastes and concepts as well) and in its willingness to countenance situations as, so to speak, somewhat aesthetic that are only distantly related to the paradigmatic structure of someone making something with the aim and effect that it be appreciated by someone else. (Consider, for example, a restaurant critic thinking of going out to review a modest suburban restaurant that a sports-writer colleague claims makes the best hamburgers in the Twin Cities area.) The test of my account of aesthetic communication, however, will not directly be a question of closeness of fit between it and some prior intuitive idea of the aesthetic. Rather it will be, first, whether the promotion of aesthetic communication, so understood, can plausibly be defended as

the function of the artworld and the practice of art, as thesis (F')
claims, and, second, whether the concept of aesthetic communica-
tion is recognizably enough related to traditional ideas of the aes-
thetic for (F') to deserve to be described as an aestheticist thesis. (And
if it should turn out that the first test is met, it might not even mat-
ter very much if the second were not.)

Here, then, are the cases. Again, keep in mind that the question for
the moment is not whether any of these situations involves art:
whether these people, acting in these situations, are artists, whether
what they produce are works of art, etc. Some of them doubtless are
cases of artists producing works of art; others clearly are not; others
are borderline in some way or other. The question for now, however,
is how they variously relate or fail to relate to the paradigm of aes-
thetic communication—someone designing and making something
with the aim and effect of someone else's appreciating it.

Cases

Pablo Picasso autographing a piece of paper and giving it to an ad-
mirer. The presentation of an object with a signature on it—a check,
say, or just an autograph—is not enough to constitute an attempt at
aesthetic communication, even if the object is valued by its recipient
not merely for its monetary value but as a memento of an admired
person—indeed, a person admired for his aesthetic prowess. Nor does
the fact that the signer and presenter is an artist necessarily alter the
case. The question is whether the transaction appropriately involves
appreciation. In the case of Picasso it is not implausible to suppose
that it does, for Picasso's signature seems to be a design affording ap-
preciation, recognizable as "a Picasso" even if it had said "Matisse."
(Something like this may perhaps be said of at least some other sig-
natures, whether of artists or not.)

Andre Agassi ending a close tennis match with a delicately struck
and perfectly placed drop volley that just clears the net. A spectator
can certainly appreciate the shot, admiring it even if he wanted
Agassi's opponent to win, but it is unlikely that Agassi has intended
it to be appreciated. The player aims to win, and "winning ugly" is

generally preferable to losing pretty (to coin a phrase). A player for whom affording appreciation took precedence over winning would probably not win many matches nor, consequently, have many opportunities to afford appreciation.

Sarah Hughes skating for the gold medal at the Olympics. Skaters are, of course, trying to win (until, having done so, they retire to a lucrative career of "exhibitions" with the Ice Capades or some similar traveling show). But part of how they win is by skating in a way that affords appreciation (by getting a high score in what the skating world refers to as "artistic impression.") "Winning ugly," while perhaps not impossible (a couple of perfectly executed triple jumps might outweigh an otherwise somewhat ordinary "artistic impression"), is not likely. That judges can even pretend to give marks under this heading (as notoriously "subjective" and even politically biased as they can be) shows that appreciation is not, as some aestheticians have held, incompatible with critical judgment. Further, a part of the aim of the competitors is to afford appreciation to the audience in a way that distinguishes this case from that of a tennis match. (Compare a pianist competing in the final public concert at which the placing in the Van Cliburn International Piano Competition is to be determined.)

Michael Sutton auditioning for a place in the violin section of the Minnesota Orchestra. The point here is not so much to afford appreciation to the members of the auditioning committee as to provide evidence of a capacity to help the orchestra to afford appreciation to its audience. That the appreciation of these listeners is not a primary aim is shown by the fact that auditions are often ended abruptly when those responsible for the decision regard the evidence as in.

Carl Andre instructing an assistant to arrange on the floor 120 bricks in a rectangle two bricks high, ten bricks long, and six bricks wide at the Tate Gallery in London and entitling the result *Equivalent VIII*. Most of the elements of a typical aesthetic communication are undoubtedly present—a designer causing something to be made and displayed with the aim that someone else looks at it. The designer and the maker are probably not the same. (I do not, in fact, know whether Andre laid the bricks out himself, but in view of the fact that no particular skill or vision is required to do so, it hardly seems to

matter.) The serious question is whether the pile of bricks is displayed with the aim and effect of affording appreciation. As to the effect, it seems unlikely that many people would find it particularly valuable to notice the pattern made by the bricks or the contrast between their rough surface and the smooth floor on which they are laid, so if the aim was to afford visual appreciation, it seems not to have been achieved. Andre, however, has made remarks that suggest that, not surprisingly in a sculpture, the work is supposed to afford appreciation when one interacts spatially with it—"the sensation [of *Equivalent VIII* when displayed in conjunction with the other pieces in the *Equivalents* series] was that they come above your ankles, as if you were wading in bricks. It was like stepping from water of one depth to water of another depth." So perhaps this is after all an attempt at aesthetic communication. (Remember that I have said nothing yet about whether or not the pile of bricks is a work of art.)

Marcel Duchamp mounting a bicycle wheel upside down on a kitchen stool and exhibiting it in a gallery. Duchamp specifically denies that this and other "readymades" were produced with any thought of "délectation esthétique" but were rather based on "indifférence visuelle" and a total absence of "bon ou mauvais goût" (good or bad taste). So it is clear that he does not propose them as objects affording visual appreciation. On the other hand, Duchamp somewhere says that he found the sound of the spinning bicycle tire "soothing," but it is hard to take him as seriously proposing them as objects of aural appreciation, either. An alternative worth exploring is that such works, though not to be appreciated by looking at them or by listening to how they sound, are to be appreciated as certain works of literature are, by understanding what they say and finding value in grasping what they say as presented in the way they say it. We do not appreciate poems by looking at them, but rather by understanding them and valuing the experience of understanding what they say as embodied in the arrangement of words with which they say it; perhaps Duchamp's action can be construed in a similar light as after all an attempt at aesthetic communication.

Picasso and Dora Maar engaging in sexual intercourse. An act of sexual intercourse may perhaps at least sometimes appropriately be regarded as a form of communication in the sense I have given to that

term, but it seems not to be a form of aesthetic communication. One reason is that the act does not typically involve one party to it making something with the aim that the other party value experiencing it. Further, even if it does, where, for example, some fetish or sex aid or erotic image is involved, the point is not for someone to appreciate the thing made in the sense I have explained. It is not something designed with the aim that coming to know it directly, by seeing or even touching it is, is to be valued in itself. What may be valued in itself in such a case, as in sexual intercourse in general, is rather the experience in something more like what I have called the phenomenological sense—how it feels, and the thing made is an instrument for rather than an object of this experience.

The character played by Stephen Rea in the film *The Crying Game*, being given sexual pleasure by someone whom he supposes to be a woman, breaking off the encounter in great distress when he discovers that his partner is a man. Cases like this show that cognitive background assumptions can be crucial to the quality of an experience in the phenomenological sense, to the extent that discovering that one is wrong about the source of the feeling can destroy it, but they do not show that sexual experience itself is experience in the epistemic sense as I understand the experience that is valued in appreciation to be.

A drug company designing, making, and marketing a pill that produces a hangover-free, nonaddictive high. Here again, though it would be surprising if no one valued the experience produced by this pill in itself, it would also be surprising if the experience thus valued was an epistemic one in the present sense. The pill is the instrument producing an experience in the phenomenological sense rather than the object of an experience in the epistemic sense.

The Rolling Stones giving a concert at the Hong Kong Harbour Fest. Certainly many of the listeners at a rock concert appreciate the music, and there may be much to appreciate in it, as the very existence of serious rock criticism shows. But there may be some for whom the music acts like a drug, so that paying attention to it and finding it valuable to track its qualities aurally, or even to move in detailed response to them, is no longer the aim, but rather being swept up in it. Others may be there to relive their lost (or perhaps only imagined) youth. Not everyone in the audience at such a concert is there with

the aim of appreciating the music. (Of course, the same can probably be said of the audience at any kind of concert, though it seems plausible that some kinds of music and some kinds of performances more than others encourage such nonappreciative responses.)

Here, then, are some cases for the reader to consider. In what ways are they like and unlike the paradigm of aesthetic communication—someone designing and making something with the aim and effect that someone else appreciate it?

- Dari Stolzoff making a collage, calling it *Bad Medicine 2002*, and displaying it on the Internet and at the Agora Gallery in Manhattan.
- Dwight Eisenhower painting a landscape with no intention of showing it to anyone else.
- Vita Sackville-West designing, planting, and tending the White Garden at Sissinghurst for her family and friends.
- Don King promoting a prize fight.
- Vince McMahon promoting a wrestling "match."
- Donna Karan designing and selling a dress.
- Dmitri Shostakovich writing and having performed a symphony to promote (or perhaps to criticize) the Soviet regime.
- Matthias Grünewald painting a crucifixion for use as an altar piece.
- Vincent van Gogh producing and trying to sell a painting to pay the rent.
- The performance artist Ben Vautier sitting in the middle of a street in Nice with a placard on which is written "Regardez moi cela suffit je suis art."("Look at me. That's all it takes. I'm art.")
- Sylvia Plath writing a love letter to Ted Hughes.
- George W. Bush writing a love letter to his wife, Laura.
- Thirteen-year-old Cody Albertson drawing an action figure and showing it to his friends.
- Johan Rohde designing the "Acorn" silverware pattern to be made and sold by the Georg Jensen company.
- The Japanese group Boredom producing and selling a "noise" CD, a collage of electronically distorted and often violent sounds.
- Ted Cohen writing and reading a philosophical paper.

- Ted Cohen telling a joke to illustrate a point in a paper on jokes that he is reading to a crowd of aestheticians.
- Ted Cohen telling a joke to a crowd of aestheticians in a bar after reading his paper.
- A pimp dressing a prostitute in seductive clothes and offering her sexual services for sale.
- A mother drawing a bath for her daughter.
- Whoopee John and the Six Fat Dutchmen playing for a dance at the New Ulm Legion Club.
- A disc jockey sampling records for a dance at First Avenue in Minneapolis.
- Bill Clinton making a speech at the Carleton College Commencement.
- The National Park Service providing a parking pull-out where the view of Mt. Rainier is particularly spectacular.
- Pianist David Tudor, having sat down at a piano before an attentive audience in a concert hall to perform John Cage's 4'33", closing the keyboard, sitting in front of the piano without moving, and then opening it four minutes and thirty-three seconds later.
- A collective of musicians from the Central Philharmonic Society of Beijing composing a piano concerto entitled *The Yellow River* in 1969.
- Jiang Qing (Madame Mao) encouraging the production of a new edition of *The Yellow River* in 1970 that has been described as more politically loaded but more musically conventional than the original version.
- Someone in Xi'an about 2,200 years ago making life-sized terra cotta models of warriors to bury with the emperor to protect him in the afterlife.
- A bricklayer instructing his assistant to put a particular slab in a particular place.
- A lathe operator at the Hillerich and Bradsby plant in Kentucky turning a Louisville Slugger bat for a major league baseball player.
- The wood-turner Mark Sfirri turning *Rejects from the Bat Factory* and displaying it at the Minneapolis Institute of Arts.
- The Nintendo company producing a Pokémon video game and selling it to Cody, who plays it on his Gameboy.

- Cai Guo-Qiang, described as "possibly the highest profile Chinese artist working on the global art scene," designing and staging a pyrotechnic display entitled *Transient Rainbow* for the opening of the Museum of Modern Art in Queens in 2002.
- One of the builders of the Neolithic passage tomb at Newgrange in Ireland scratching designs in the large boulders that surround its base.
- Someone playing an erhu, a Chinese bowed musical instrument with two strings, in the subway outside the Hong Kong Cultural Centre before and after concerts.
- A beachcomber picking up a piece of driftwood and displaying it on her mantel.
- Beethoven beginning his Symphony no. 1 with a seventh chord on what turns out to be the tonic, and a knowledgeable listener today recognizing this as a shocking dissonance at the time it was composed.
- Richard Strauss climbing a mountain near Garmisch-Partenkirchen and watching the sun rise before a storm in the Alps.
- Richard Strauss's writing his *Alpine Symphony* and providing programmatic titles ("Sunrise," "On the Summit," and "Tempest and Storm," etc.) and a narrative (the sun rises, the climber reaches summit, there is a storm, etc.)
- The writer and critic John Wain taking the phrase "dark Satanic Mills" in the preface to William Blake's *Milton* to be a denunciation of the horrors of the Industrial Revolution, despite the fact that the industrial mills of the English Midlands came into existence only after Blake wrote.
- Pinin Brambilla Barcilon cleaning and restoring Michelangelo's *Last Supper* in the Vatican.

The Artworld and Practice of Art

Practices

Practices, at a minimum, are activities regularly engaged in by a significant number of people. Farming, competing in beauty pageants, attending high school football games on autumn Friday evenings, attending church on Sunday mornings, going "up to the lake" for summer weekends, for instance, are practices that are characteristic of rural Minnesota at the beginning of the twenty-first century.

Practices are frequently more-or-less local both in time and in place. None of these practices in rural Minnesota (with the possible exception of farming) antedates the nineteenth century. Some of them (perhaps farming and attending church on Sunday mornings, for example) are less prevalent now than they were only a few decades ago. Perhaps none of them could now be said to be a practice in the main urban center of Minnesota, the Twin Cities area of Minneapolis and St. Paul (not to mention Hong Kong or rural Pakistan).

Practices have a history—a beginning, a period of development and

change, and (no doubt in the long run inevitably) an end. Farming in Minnesota has recently undergone great changes technologically, socially, and economically. The practice of families (often extended families) sitting down for a large Sunday dinner in the early afternoon is all but extinct. The practice of families gathering to watch favorite TV shows, obviously not one of long standing, has also virtually vanished. And, lest one think that any practice's changing or becoming obsolete is an occasion for nostalgic regret, it is worth observing that the practice of systematically discriminating against Native Americans, though by no means extinct, is less prevalent in Minnesota than it once was.

Institutional Facts

What makes an activity regularly engaged in a practice is the further fact (beyond its being regularly engaged in) that there are in effect among those who engage in it what John Searle calls *constitutive rules*. The rules of chess, for example, are constitutive

> in the sense that playing chess is constituted in part by acting in accord with the rules. If you don't follow at least a large subset of the rules you are not playing chess. (Searle 1995, 28)

Such rules typically

> take the form "X counts as Y" or "X counts as Y in context C." Thus such and such counts as a checkmate, such and such counts as a legal pawn move, and so on. (Searle 1995, 28)

Regulative rules, in contrast to constitutive rules, regulate an already existing activity, which may be carried on without them. It is possible, if inconvenient, for people to drive automobiles without there being rules of the road; such rules are thus (merely) regulative.

Associated with constitutive rules are *institutional facts*, such as the fact that George W. Bush is President of the United States, facts that can only exist within human institutions. Someone (X) counts as president (Y), the constitutive rule might run, in the context (C) of

having been duly certified by the Electors and sworn in by the Chief Justice. If no such rule were in effect someone might have the power that a president might have, but no one would have presidential authority, in the same way that, as things now stand, a person other than the person who has presidential authority may have the power of a president (e.g., President Woodrow Wilson's wife, after he suffered a severe stroke).

Searle distinguishes institutional facts from *brute facts*, facts like the sun's being approximately 93 million miles from the earth. Such facts exist independently of any human institutions, in Searle's view, though he does concede that for such facts to be stated, there must be in place a practice of speaking a language (e.g., English), including constitutive rules such as one stating what counts as referring to the sun in that language, and a practice of measuring distances in miles, including a constitutive rule stating when a distance *counts as* a mile.

The "counts as" locution and the associated notion of an institutional fact thus mark out a realm at the intersection of the descriptive and the normative, of facts and rules. It is a fact that, for instance, a certain stone is a piece of marble, and it could well have been a fact even before anyone ever thought about stones and marble. The stone does not count as a piece of marble; it simply is one. It is a fact that, for instance, a person has hit a spheroid with a stick in such a way that another person has caught it before it hit the ground. The person's action does not count as a case of hitting a spheroid with a stick; it simply is one.

It is a regulative rule that one ought to sacrifice a pawn (as it might be, a piece of marble) under such-and-such circumstances whether or not in fact someone does sacrifice it under those circumstances; it is a regulative rule of baseball that one ought to try to hit a sacrifice fly (by hitting the ball in the air far enough that someone catches it a sufficient distance away to allow the runner on third base to reach home safely after the catch) under certain circumstances whether or not someone in fact tries to do so.

That a particular piece of marble is a pawn or a particular hitting and catching of a ball a sacrifice fly (and therefore not a time at bat for purposes of calculating a batting average) are facts. In contrast, however, to the stone's being a piece of marble or a motion's being the

hitting of a ball with a stick, they are facts only because a number of people—including at least those who play chess or baseball—think of the piece of marble as a pawn or the hitting and catching of the ball as a sacrifice fly. They are pawns or are not times at bat, not "simply" but only because there are constitutive rules in effect among members of a group to count them as pawns or as sacrifice flies. That some piece of stone is a pawn or some hitting and catching of a baseball a sacrifice fly are institutional facts.

(A story about the legendary baseball umpire Bill Klem—all umpire stories seem to be about Bill Klem—nicely illustrates his firm grasp of the concept of an institutional fact. A runner slides home as the catcher attempts to apply the tag. The play is close; both players look expectantly at Klem, the home-plate umpire, who says nothing. Eventually the runner asks, "Well, what am I, safe or out?" Klem replies, "You ain't *nothing* until I say so!")

The distinction between institutional and brute facts is not always easy to apply. Where, for example, would the fact that two specific pawns are now less than six inches apart fit into the picture? On the one hand, there cannot be pawns in the absence of constitutive rules specifying what counts as a pawn. On the other, there plainly does not have to be any constitutive rule recognized by and in effect among chess players saying what counts as being less than six inches apart in order for two of what they recognize as pawns to be less than six inches apart. There are places where no such rule would be recognized and in effect—perhaps places that never fell under the cultural sway of Britain or, more recently, America and thus never measured distances in feet and inches—where it is nonetheless possible and probably frequently true that two pawns are less than six inches apart.

Perhaps the most natural way to deal with such a case would be to say that, since it is clearly nonbrute in virtue of its having, as it were, institutional components, it should be classified as an institutional fact. A consequence of this move, however, is that we lack a way to distinguish between facts that are institutional in the sense that their existence depends on there being in effect constitutive rules saying what counts as a fact of that kind (e.g., the fact that a certain piece of marble is a pawn) and facts that are institutional in the somewhat weaker sense that their existence depends on there being in effect

some constitutive rule saying what counts as a fact of *some* kind (e.g., in the way the fact that two pawns are less than six inches apart depends for its existence on there being in effect a constitutive rule specifying what counts as a pawn, but not on there being in effect any constitutive rule specifying what counts as two pawns being less than six inches apart).

Facts of the first kind I shall call *primarily institutional facts,* while facts of the second kind may be called *derivatively institutional facts.* Thus, the facts that George W. Bush is president and that certain pieces of marble are pawns are primarily institutional facts, while the fact that two pawns are less than six inches apart is only derivatively institutional. (That two pieces of marble are less than six inches apart remains a brute fact, even if the two pieces of marble happen to be, "primarily-institutionally," pawns, and even if their being less than six inches apart was caused by a human action whose intelligibility depends on its being a primarily institutional fact—e.g., somebody's having made a certain chess move.)

We can now say that for an activity to be a practice, the fact that someone is a participant in it must be not merely an institutional fact in the sense of being nonbrute, but a primarily institutional fact in the sense just specified. Accordingly, we can distinguish between someone's going to church and someone's being a churchgoer (participating in the practice of a religion); between someone's going to a high school football game and someone's being a fan (participating in the practice of high school football); between someone's planting, tending, and harvesting some fruits and vegetables and someone's being a farmer (participating in the practice of farming). (That someone attends a church service or a football game are evidently derivatively but not primarily institutional facts; that someone tends some plants may well be a brute fact.)

Nor is the distinction merely one of how often or how regularly one engages in these activities—one can attend church regularly without being a churchgoer; one can attend many high school football games without being a high school football fan; one can plant lots of seeds, tend lots of plants, and pick lots of fruits and vegetables without being a farmer.)

What makes someone a churchgoer, a high school football fan, or a

farmer, in addition (typically) to engaging regularly in appropriate activities, is fulfilling the conditions of some constitutive rule that specifies who counts as a churchgoer, a high school football fan, or a farmer. Typically such a rule requires one's being recognized as such, generally both by oneself and by appropriate others, but perhaps only by others or only by oneself. This recognition, however, need not take the form of being certified by or accepted as a member of a formal institution. It is evident that one can be a farmer without having a degree in agriculture or belonging to the Grange or any similar organization or be a fan without belonging to the Boosters' Club—the rule is not that to count as a farmer or a fan one must have an appropriate credential. It is perhaps less obvious but, I think, equally true, that one can be a participant in the religious life of a church without being a member, for example, by not only attending services regularly but also seeing oneself and being seen by others as a participant.

There can exist a practice and people can be participants in a practice without there being formal institutions associated with that practice, but only if there exist people who have a concept of that practice. There can be no farmers unless someone is capable of thoughts of the form "She's a farmer" and "He's not a farmer," even as there might well be, and at one time undoubtedly were, people who planted, who tended plants, and who picked fruits and vegetables even though no one was capable of thoughts about farming or had the concept of farming.

Worlds

Where there exist practices that are of absorbing interest to those who engage in them—for instance, religions such as Lutheranism, professions such as the law, occupations such as farming, businesses such as the toy business, avocations such as glass collecting—it is common to speak of the *worlds* of those practices, where a world is a group of people, the members of the world, who recognize one another as engaged in a practice in various ways and to various degrees. We thus speak of the world of the Lutheran church, the legal world, the agricultural world, the toy world, and the world of glass, and it would

not be surprising to find that there were publications with titles like *The Legal World* or *Farmers' World.*

(Locutions like "the English-speaking world," unlike the examples just given, seem to have more of the strictly geographical sense of uses of the term in expressions like "world-traveler" or "New World," but this may simply be because participants in the practice of speaking a given language are typically concentrated in identifiable geographical areas.)

Worlds in this sense are institutions, but they are not formal institutions. That is to say, they are institutions in the sense that their existence in virtue of a web of mutual recognition among their members makes possible the existence of such primarily institutional facts as the fact that someone is (counts as) a churchgoer, a football fan, a farmer, and so on. But worlds do not have constitutions, formal requirements for membership, official publications, annual meetings, officers, and so on. One may need a credential to be a lawyer (if not to be a farmer), but lawyers are not the only members of the legal world, even as farmers are not the only members of the agricultural world. There are law book publishers and editors of farm magazines, manufacturers and sellers of legal software and farm machinery, legal aids and county agricultural agents, professors of law and professors of agriculture. Not all of these people require a formal credential (a degree, for example, or a certificate of having passed a test) to play their part in their world, but some do. Thus the informal institution that is a world can usefully be viewed as typically comprising not only individual members but institutional members as well, where those constituent institutions may well themselves be formal institutions—churches, colleges, boards of certification, state agencies, commercial enterprises, professional organizations, fraternal organizations, nonprofit foundations, and so on.

Art as a Practice and the Artworld as an Informal Institution

My claim is that art is a practice and those who participate in it are members of the informal institution of the artworld. (Henceforth, when the term *art* occurs, it should be understood as referring to this

practice. In particular, the term *art* will not refer to works of art un-
less such reference is explicit or obvious from the context.)

The very existence of artists, works of art, artistic audiences, art
critics, art dealers, art museums, art schools, and so on, is metaphys-
ically dependent on people having concepts such as *artist* and *work
of art*, hence the capacity to understand and apply constitutive rules
having the form "A person (X) counts as an artist (Y) under such-and-
such conditions (C)" and "An artifact (X) counts as a work of art (Y)
under such-and-such conditions (C)," hence the capacity to recognize
other people as engaged in a common enterprise or certain objects as
products of that enterprise. (Again, I do not exclude the possibility of
there being an artist who failed to recognize that she was an artist or
who was not recognized by anyone else as an artist. What I exclude is
only the possibility of there being an artist if there does not exist some
such web of mutual recognition.) That a person is an artist or an ar-
tifact a work of art are primarily institutional facts that could not ex-
ist without the existence of the practice of art and the artworld.

Aesthetic Communication and Artistic Communication

Parallel to instances of aesthetic communication—someone de-
signing and making an artifact with the aim and effect that it be ap-
preciated by someone else—we can describe instances of *artistic
communication*—an artist creating a work of art with the aim and ef-
fect that it be valued in some way by an artistic audience. (Note that
I say "valued in some way" rather than "appreciated"; I do not want
to assume that every work of art is intended to be valued in the spe-
cific way that is part of what I have called appreciation.)

That artistic communication thus described has occurred is clearly
a (complex) institutional fact, many, if not all, of whose components
are primarily institutional facts. That someone is an artist, that some-
thing is a work of art, that an audience is an artistic audience—all of
these, as I have said above, seem to me to be primarily institutional
facts, depending for their existence on the acceptance within the art-
world of constitutive rules concerning what counts as an artist, a
work of art, or an artistic audience. It seems to me possible, but not

certain, that the fact that something is created (as opposed to merely being designed and made) is also primarily institutional, but certain that someone's having an aim, something's having an effect, and someone's valuing something are not primarily institutional. (That an instance of artistic communication has occurred depends on what having an aim, having an effect, and valuing consist in, but not, I think, on anything that could be called what counts as having an aim, having an effect, and valuing.)

In contrast, the fact that aesthetic communication has occurred, though hardly a brute fact in Searle's sense, does not comprise as many primarily institutional facts and, specifically, does not depend for its existence on the existence of the artworld or the existence of any facts that depend for their existence on the existence of the art- world. Arguably none of the concepts required to explain what aes- thetic communication is—human being, making, aiming, causing, appreciating (that is, valuing experiencing)—is primarily institu- tional. It seems plausible to say that any of these concepts could be instantiated even if no one had them and, consequently, there were no constitutive rules recognized anywhere that specified what counts as a human being, what counts as making, what counts as experi- encing, and so on. If one substituted "person" for "human being," this strong claim might well fail, but in any event the central point re- mains: Aesthetic communication could exist even if there were no artworld, while artistic communication could not.

Since it is obvious that many instances of aesthetic communica- tion are in fact also instances of artistic communication and that many instances of artistic communication are also instances of aes- thetic communication, my attempt to treat the concepts of the aes- thetic and of the artistic as independent of one another may seem overly fastidious. But there are phenomena that at least appear to ex- emplify something like *aesthetic nonart*—natural scenes proposed, if not designed and made, for appreciation, perhaps even fully fledged instances of aesthetic communication, as when a chef prepares and serves a meal—the aesthetic outside the artworld. As well there seems to be *nonaesthetic art*—instances of artistic communication involving conceptual artists, such as Ben Vautier's "creation" and pre- sentation of himself as a work of art—art that does not seem to be

aesthetic in that it neither aims at appreciation in the sense I have explained nor does it seem likely to afford it. So it seems important to explain the concepts of art and of the aesthetic, to the extent possible, independently of one another, in preparation for the arguments for thesis (F') that, as a matter of fact, but not of conceptual necessity, the function of the artworld and the practice of art is to promote aesthetic communication.

The Concept of the Artworld

The notion of the artworld has been used in different ways. Within the artworld itself, the term sometimes seems to refer primarily to people and institutions at the centers of fashion and of current taste in painting, sculpture, and related visual arts (currently perhaps mainly somewhere on Manhattan Island, though there can be acolytes and satellites as far away as Bilbao or even Minneapolis). Sometimes the reference seems to be even more specifically to those who help to mold fashion and taste in those centers not as artists but as critics, dealers, curators, teachers, collectors, and to constituent formal institutions such as galleries, museums, art schools, periodicals, and so on. The word so understood often seems to carry at least a hint of distaste, as if such people might have interests and motives that were not always consonant with some higher aspirations of artists.

The term was introduced into philosophy in a very different sense by Arthur Danto (1964), himself a fully paid-up member both of the artworld in the sense just discussed as a critic in Manhattan and of the philosophical world as a professor of philosophy. The artworld for him is not a group of people and institutions that in various ways cluster around works of art, but rather "an atmosphere of artistic theory: a knowledge of the history of art" (Danto 1964, 16) that hovers in the background, in the light of which works of art are created and apart from which it is impossible truly to understand them, to grasp the works as they are, or even to tell that they are works of art.

George Dickie (1974), with an explicit bow to Danto, but understanding the notion in a different way, introduced the notion of the artworld into philosophy in much the way I want to use it—referring

to a set of people and institutions involved in different ways in the practice of art, that set being conceived in a very broad way. It is not limited to those in the visual arts; it does not exclude artists (painters, composers, actors, novelists, etc.) themselves; it is not necessarily limited to people and institutions of our time and culture. Though it seems plausible to say that at the present time (and perhaps since the mid-twentieth century) a certain group of people and institutions concentrated in one part of one island in the northeastern United States is and has been one of its main centers, it is not limited to these people and institutions nor to their friends and members. Dickie goes so far as to say that anybody who "sees himself as a member of the artworld is thereby a member" (1974, 36); I will go further in suggesting in addition that anyone who is seen by other members of the artworld as a member of the artworld is thereby a member.

It is this perhaps somewhat broadened version of Dickie's idea of the artworld, in contrast with the popular idea and with Danto's conception, that is the starting point of my discussion.

The Beginning of the Western Artworld

The artworld as so conceived is undoubtedly a Western institution. When did it come into existence? When did painters, composers, poets, etc., come to have the conceptual capacity and the inclination to recognize one another as artists in the sense in which I take this recognition to be necessary for the artworld to exist?

There was, of course, some concept of art in the ancient Western world, but it was not ours (as anyone who has read, perhaps with initial puzzlement, Plato's references to the "art" of the cobbler or the statesman will recognize). And if I am right about the institutional status of art and what that entails about the availability of the concept of art, it was not until something like our concept of art became extant—sometime in the mid-eighteenth century, as Paul Kristeller (1951) has argued—that there could be works of art. (On the other hand, if, as seems clear, aesthetic communication can take place without any of those involved having or invoking anything like the concept of the aesthetic, the fact that that concept also emerged at

about the same time, though perhaps not accidental, does not imply that no aesthetic communication took place before then.)

Undoubtedly there existed well before the eighteenth century some of the component worlds that are now part of the artworld—the world of poetry, say, or the world of painting. (That there were, therefore, paintings—and not just artifactual images—in the ancient world but that they were not then painted works of art seems to me only a verbal paradox.) Furthermore, there was the Horatian tradition of comparing poems and pictures, but these comparisons typically fell far short of claiming that poems and pictures fall under some generic concept of art. Moreover, for most of the history of this and related comparisons, any generic concept that might have subsumed them both (e.g., the "liberal arts") typically did not include music, for instance, while it did often include such things as grammar.

When in 1746 Charles Batteux finally grouped together music, poetry, painting, sculpture, and dance as the *"beaux arts"* (fine arts), he was not, of course, inventing the modern conception of art; he was rather making explicit something that was happening or had happened already. Participants in these practices were evidently coming to recognize one another not only as poets, say, or painters but also as participants in a larger practice of which poetry and painting were subpractices. Versions of Batteux's scheme were quickly taken up and, given the imprimatur of writers such as Jean d'Alembert and Denis Diderot in the *Encyclopédie* and spread in translations and paraphrases to Germany and England, came into wide use (Shiner 2001).

It seems reasonable to suppose, then, that the practice of art and the Western artworld as they now exist—presupposing as they do recognition by painters, poets, composers, etc. that they were all engaged in a larger common practice—came into existence sometime after the middle of the eighteenth century.

The Western Artworld and Other Artworlds

The recognition that the artworld I am discussing is a phenomenon of Western (developed, literate) culture invites the question whether there are or were artworlds in non-Western or less-developed or pre-

literate cultures; there certainly is no a priori reason why there should be only one artworld.

First, it is worth remembering that aesthetic communication in the sense I have explained evidently occurred and now occurs in non-Western cultures or preliterate or less-developed cultures. Jacques Maquet (1986), though invoking a concept of the aesthetic closer to traditional aestheticism than it is to the view defended here, cites nonfunctional decoration in prehistoric artifacts as evidence of pre-literate aesthetic aims. Presumably it would not be difficult to cite similar evidence in ancient and contemporary non-Western cultures, both fully developed and less developed. (The traditional aestheticist view of the aesthetic as disinterested, nonpractical, formally oriented, and so on, that evidently influenced Maquet in effect sets the bar higher for inferring the presence of the aesthetic than does the view that I have defended; evidence sufficient to infer the presence of the aesthetic in the traditional view is thus in general sufficient to infer the presence of aesthetic communication in the current sense as well.) But, of course, it is central to my argument that the aesthetic is perfectly conceivable and has in fact existed prior to the existence of an artworld.

More to the point is the question whether, given that people drew, told stories, sang songs, etc., for one another in these cultures, these activities amounted to practices with their associated worlds? Was there a Paleolithic cave-painting world; is there a gamelan world in Java; was there or is there a world of calligraphy, or of scroll painting, or of pipa playing in China?

The *New Yorker* has recently been obsessed by the first question. A cover a few years ago showed troglodytes chatting and sipping wine at the "opening" of the "show" of animal paintings in the cave at Lascaux; another recent drawing shows similar people (without the wine), one saying to the others, "Maybe someday we could set aside a whole cave just for art." The point that art can exist without an artworld in the popular sense is clear enough, and it is particularly appropriate for the *New Yorker* to make fun of thoughts to the contrary—as if there could be no art without the gallery openings and museums that typify the current New York artworld—but it remains

moot whether there was a world of cave painting in the relevant sense.

On the other hand, apparently gamelan players in Java do recognize one another as engaged in a common enterprise and constitute a world in the present sense, and it seems clear that there was in medieval China, for example, a world of scroll painting, as contemporary critics almost obsessively assigned scroll painters to schools. (The practice and the world of scroll painting continue to exist.) So it seems clear that there have been and are worlds and practices in non-Western and indigenous cultures in the sense that there are worlds of painting, poetry, etc. in the West.

This still leaves us with the question whether there are or have been other artworlds in the present sense—worlds in which practices comparable to what in the West we have come to call the fine arts make common cause. I defer to others on this question; this clearly would, in my view, require that the cultures supporting these worlds have concepts closely akin to the Western concept of art that emerged in the eighteenth century, and we are frequently told that various cultures do not have "our concept of art."

In any case, my concern is with the Western artworld, and the important point for the present is that, for good or ill, many of these non-Western or indigenous worlds have at least in part become subpractices of the Western artworld. That is, mutual recognition in fact holds between relevant people and institutions in New York and other Western artworld centers, on the one hand, and, say, gamelan orchestras in Indonesia, art schools in Chongqing, bark painters in the Australian Outback, and Inuit printmakers in Arctic Canada.

The Artworld and the Worlds of the Arts

Batteux's *beaux arts* consisted of poetry, painting, sculpture, music, and dance. Even as the concept of art began to spread, this list was fair game for revision, where revision typically but not invariably meant expansion.

Combinations of elements of these arts—theater, song, opera—are

prime candidates for inclusion. New technology has led to the un-
doubtedly artistic practices and worlds of photography, cinema, and
video art. Forms of popular entertainment, such as jazz, have become
arts. Some of the practitioners of such traditional crafts as potting,
glass-blowing, wood-turning, and furniture-making are widely re-
garded as artists. Some practices and worlds—fashion, gastronomy,
gardening, even architecture—have been and remain contested cases
as artistic practices.

In general, the Western artworld, if one thinks of it as depending on
recognition among practitioners and their worlds, and especially if
one allows for the possibility of artists or arts that are recognized as
such either only by others or only by themselves, is a capacious in-
stitution.

Identifying the Artworld

That there is such an informal institution as the artworld seems to
me incontestable (though some may not think it obvious that the
very existence of artists, works of art, and so on depends on its exis-
tence).

Since my central claim is that as a matter of fact this institution
has an aesthetic function, it is important for my project that it, its
members, their characteristic products, and its subinstitutions be
identifiable, to the extent that they are identifiable, without appeal-
ing to the concept of the aesthetic. I have tried, therefore, to be
scrupulous in simply recording what seem to me to be the facts about
mutual recognition or lack thereof that are relevant to the questions
whether a practice is an art or a person is an artist.

Indeed, I think anyone who is reasonably literate in Western cul-
ture and socially aware can readily identify some people and institu-
tions that are central to this Western artworld, some that have
nothing to do with it, and some that are in various ways on its mar-
gins or whose status with respect to it is contestable. In so doing they
identify some people as undoubtedly artists (or participants in the
practice of art in other ways) and some artifacts as undoubtedly works
of art (primary products of that practice). In the same way, they can

identify some people as undoubtedly not artists (or critics, or dealers, etc.) and some artifacts as undoubtedly not works of art, and some people and artifacts as of marginal or uncertain status.

As with many issues of this sort, there seems to me to be little point in trying to deliver definitive judgments on borderline cases. The capacity to deliver such judgments as I have just described, however, seems to me to be a capacity for relatively straightforward sociological observation, not requiring much theoretical sophistication. In particular, it does not require that one have any opinions at all about the "nature of art," beyond the fact that it is a practice with an associated world, or about the notion of the aesthetic or of appreciation as I have outlined them. In fact, such opinions are as likely to hinder as to help us in asking such fundamentally sociological questions as "Is this person an artist?" and "Is this artifact a work of art?"

Having given an account of art in this chapter and an account of the aesthetic in the preceding chapter, I turn next to the concept of a function. Before moving on, however, the reader might usefully return to the cases proposed for discussion at the end of Chapter 3, now having in mind not so much the question whether or not they exemplify the aesthetic as I there explained it but rather the question whether they exemplify art as I have just described it. (Once again, the answers that my account suggests should be thought of not merely as consequences of it but as tests of it as well.) It will be particularly interesting to reflect on cases that might plausibly be taken as exemplifying aesthetic nonart or nonaesthetic art.

The Artifactual Concept
of Function

Theories of the Function of Art

There is, as David Novitz has observed, "no shortage of . . . theories" about the function of art" (1992, 164). Traditional aestheticism, as exemplified by thesis (F), involves the claim that the function of works of art is fundamentally an aesthetic one. Others, though perhaps not always explicitly observing the distinction between works of art and the practice of art, have made claims that seem most reasonably interpreted as being about the function of the practice (and the informal institution)—for example, Karl Marx's claim that art's function is to advance the economic interests of certain groups of individuals within society and Ortega y Gasset's claim that art's function is to provide a social safety valve (see Novitz 1992).

Thesis (F'), the claim that the function of the artworld and the practice of art is to promote aesthetic communication, is like these latter claims in being about the practice of art rather than about works of art, but it is like the claim of traditional aestheticism in appealing to the idea of the aesthetic.

A final preliminary task in explicating thesis (F′) prior to defending it is to clarify how the notion of function is to be understood in it.

Two Concepts of Function

We say that the function of a certain blade on my wife's Swiss Army knife is to cut and that the function of the heart is to pump blood. These two attributions of function are paradigmatic of what seem to be two different conceptions of function: an *artifactual* conception and a *systemic* conception.

Note first, though, that these two claims have quite a bit in common. First, part of the evidence for either might be that the thing in question is *good* at doing whatever its alleged function is—the blade is good at cutting and the heart is good at pumping blood. But this would be neither necessary nor sufficient for the truth of either claim. Something may not be good at fulfilling its function (the main blade of a cheap knockoff of a Swiss Army knife may be pretty bad at cutting, and a defective heart may be pretty bad at pumping blood). Furthermore, a thing may be good at doing things other than fulfilling its function (the blade of a knife may be pretty good at prying out staples, and a heart may be pretty good at producing a sensation of a regular beat in the organism whose heart it is).

Another idea that our two examples have in common—a point that takes us deeper into the concept of a function—is that the concept of function has a strong *explanatory* dimension. (See, e.g., Larry Wright 1976, 78, and Peter Godfrey-Smith 1995, 187–88.) When we say that the function of the heart is to pump blood or that the function of a knife blade is to cut, we are at least gesturing at explanations of why creatures have hearts and why a Swiss Army knife has a particular blade.

Artifactual Functions

Differences emerge, however, when we begin to consider the kinds of explanations toward which we gesture in the two cases. In the case

of the knife, but not in the case of the heart, the explanation in question is an explanation in terms of the intentions and actions of a conscious agent—this particular blade is on the knife because someone designed it and someone had it made to be good at cutting (and not because someone made it to be good at removing staples). Since things designed and made in accordance with that design are paradigmatically artifacts, it is appropriate to refer to this notion of function, backed as it is by explanations in terms of design and construction by conscious agents, as an *artifactual* notion of function.

Now artifactual functions seem straightforwardly to be functions. That is, although there are, no doubt, difficulties in particular cases in determining who designed something (even whether or not it was designed) or what it was designed for (think of implements in agricultural museums), still, to the extent that we are confident that something is good at doing something (at least in part) because someone designed and constructed it to do just that, no conceptual difficulties stand in the way of our saying that doing just that is its function.

It seems reasonable, then, to propose something like the following not as an analysis of the concept of an artifactual function but rather as a candidate for a plausible sufficient condition for attributing such a function:

> (AF) If something is good at doing something that it was
> designed and made to do, then doing that is its
> (artifactual) function.

One can imagine possible counterexamples to (AF) in which the match between what something was designed and made to do and what it is good at is a lucky accident—something might do what it was designed to do but not in the way it was designed to do it. Any full treatment of the concept of an artifactual function would have to deal with such problems. For my purposes, however, it will be sufficient to claim that (AF) can be relied on in cases where such considerations do not come into play, for there will, I think, be no reason to suppose that they do in the case in which I propose to invoke it.

Systemic Functions

When, on the other hand, we say that the function of the heart is to pump blood, the concept of function invoked is, unless one is inclined to accept some version of the Argument from Design for God's existence, evidently not the artifactual concept of function, so that, if one takes the artifactual concept of function as paradigmatic, such attributions may appear at least initially to be on shakier conceptual ground.

One response at this point would be to withdraw as illegitimately anthropomorphic the claim that the function of the heart is to pump blood. Another would be to try to reduce the idea of function to some less fraught notion—say, the notion of a necessary condition. If, with eliminative materialists, we thought it was illegitimate to attribute even to people the folk-psychological states typically invoked in describing someone's consciously designing something, we might imagine that in this way we could achieve the desirable result of freeing even attributions of functions to artifacts from conceptual dependence on the idea of conscious design and thus restoring parity between functional claims about artifacts and functional claims about organs.

More promising than either of these rather desperate responses, though, is the attempt to spell out the notion of explanation behind attributions of function in such a way as to subsume both obviously artifactual attributions (the knife-blade) and clearly nonartifactual ones (the heart) while still maintaining that being a product of conscious design is crucial to the blade's, but not the heart's, having the function it does. Much recent work on the concept of function, stemming from Wright (1976), is motivated by this urge to make functional claims in biology immune to charges of illegitimate anthropomorphism.

Our explanations begin, then, by saying that there are hearts in organisms because they pump blood and that there are certain blades on Swiss Army knives because they cut. So far, both stories are the same, but now they diverge. When we ask "Why do they do that?" the story about the heart, unlike the story about the blade, requires that we talk not about someone designing it to do that but rather

about the organic system that an animate body of a certain complexity is and the contribution that the circulation of the blood makes to the maintenance of that system (as contrasted with any alleged such contribution of the heart as a producer of regular beating sensations).

Functions like the heart's function of pumping blood, then, might be called *systemic functions,* and where such functions are attributed to parts of living organisms the explanation invoked in attributing them will presumably be those of evolutionary biology. (The answer to the question of why there are creatures capable of conscious design, of course, might require appeal to evolutionary biology just as much as the answer to the question of why there are organic systems of the sort that need circulating blood, but the point is not that attributions of artifactual functions are free of what might be called biological commitment but rather that attributions of systemic functions are, in general, free of psychological commitment.)

Note, however, that there can be artifactual systems for which both kinds of explanations may come into play. A certain part of a computer program may have the function, say, of screening for viruses, both in the sense that that is what it does in the internal economy of the system and in the sense that someone designed and made it to do that. Or something may have a certain artifactual function—what it is designed for, made for, and good at—while also being part of a system to which its contribution—and hence its systemic function—is something quite different. Attributions of systemic functions and of artifactual functions being conceptually distinct, there is no conceptual bar to attributing both a systemic function and an artifactual function to the same entity, provided that it is relevantly analogous both to an artifact such as a blade and to an organ such as a heart.

Institutions as Artifacts

My claim is that institutions and practices, such as the informal institution of the artworld and the practice of art, can be regarded as artifacts for the purpose of applying (AF) to them; (F′) is a claim of artifactual function. My interest in claims about the systemic function of art is therefore marginal. What is important for my purposes

is that there is no necessary conflict between (F') and the claims of a Marx or an Ortega, which seem clearly to be claims about the systemic function of art in the social organism. I say a little more about such claims below, but the main aim of the rest of this chapter is to make plausible the claim that the practice of art and the informal institution of the artworld are sufficiently analogous to knife-blades for the attribution of an artifactual function to them to make sense. If this is so, then the way will be clear to invoke (AF), which claims to state a sufficient condition of artifactual functionality, in an argument for the claim of artifactual functionality embodied in (F').

Formal Institutions as Artifacts

Before directly considering the claim that practices and informal institutions, such as art and the artworld, can be regarded as artifacts, it will help to consider analogous claims about formal institutions, such as the Evangelical Lutheran Church in America, the Grand Army of the Republic, the March of Dimes, the Minneapolis College of Art and Design, and the like.

Abstracting from the fact that not some thing's being an artifact but rather some state of affairs' existing artifactually is the basic notion in the neighborhood, and remembering that artifacts need not be physical objects, events, or processes, it seems clear that the Minneapolis College of Art and Design is as much an artifact as is a Swiss Army knife or the Megalithic passage tomb at Newgrange in Ireland or William Blake's *Milton*, and one can attribute an artifactual function to it with considerable confidence.

Starting from the observations that what it is good at—what it does—is, let us say, to provide an education in the visual arts, we next ask what the explanation of its doing that is, and the answer will centrally include something of the general form "it was designed and made to do that." We can find out who designed it (who wrote its charter) and who made it (who its founders were). We can trace its history, from when it was made to the present. We can say what it was made to do, as stated, for example, in its charter, articles of incorporation, constitution, etc. We should in principle have no difficulty filling in

the blanks in principle (AF) in such a way as to emerge with a well-grounded claim as to what the artifactual function of the Minneapolis College of Art and Design is.

There are many ways in which this relatively straightforward picture can quickly become complicated. For one thing, what the founders of an institution, wearing their founders' hats, say they are founding the institution to do may not be what they are really founding it to do. Acting in their official role, they may say that their school exists to provide education in the arts, but it may be just a diploma mill that exists to pad their own purses by selling a worthless "credential" to the gullible. In this case, of course, given that something's artifactual function is what it does because it was designed and made to do that, the mismatch between what the institution does and what it is claimed to have been designed to do implies that what is officially claimed to be its function is not, and that, if it does have an artifactual function, the founders have lied about what that function really is.

In another kind of mismatch, an institution may truly have been designed to do something that it is unable to do; here, what it was designed to do is (only) its intended function. (Remember those films of hilariously disastrous tests of early attempts at flying machines of one sort or another.) So it may be difficult to say what an institution was really designed to do, and what it was designed to do and what it does may not match, but where they do match and we can tell that they do, the inference to a claim of artifactual function licensed by (AF) seems justified.

A different question arises when an institution has officially been founded, say, to provide education in the arts and does so, but the founders also (and perhaps primarily) wished to make their city more attractive and, hence, prosperous, or (if it is a proprietary institution) wished to make a profit for themselves. In such cases (supposing that these institutions are not, like the diploma mill, fraudulent), is it legitimate to identify education in the arts as the function of the institutions?

Note, first, that often in attributing an artifactual function, we can readily identify *the* function of the artifact in question, even where it can do other things. The—not merely "a"—function of this blade is

to cut. Of course, there are artifacts—think of some of the kitchen gadgets offered on shopping channels, as well as the Swiss Army knife itself—that have multiple functions, but these are surely atypical. Perhaps more frequently artifacts designed and made to do one thing and able to do it can also do other things as well. Something designed and made to cut and good at cutting in the way a knife-blade is may turn out to be pretty good at prying up thumbtacks as well.

The case of the legitimate art school whose founders wish either to make a profit or to promote the local economy is, however, different. It is rather a case in which the purposes of the designers of an artifact are "nested" in various ways. The designer of the blade on the Swiss Army knife may have had such overriding aims as benefiting himself or his company or bolstering the local economy or improving the Swiss Army. Furthermore, supposing that he succeeded in all this, that the blade contributed to all these intended effects would surely be part of the explanation of why it is there. Even if the Swiss Army knife's main blade does all this and its designer intended it to do all this, however, its *artifactual function*—what it does that it was designed and made to do—is still to cut. These other effects, even supposing that they are expressly aimed at and achieved, are, where they are not the result of fraud or serendipity, contingent on the blade's fulfilling its artifactual function. So it is in the case of the art school. While always prepared to make due allowance for failure, fraud, deceit, self-interest, self-deception, ulterior motives, multiple or unintended effects, and so on, we can surely take the official avowals of the designers of an institution concerning what it is for as prima facie evidence of its function. If an institution's constitution or charter says it is for providing education in the arts and it does so, then, in the absence of defeating evidence, we are entitled to infer that its artifactual function is to do just that.

Other problems are raised by the fact that institutions may change their functions or deteriorate and become moribund. The March of Dimes was founded to fight polio. When polio was virtually eradicated, the March of Dimes turned its attention to other problems of children such as birth defects and conditions that contribute to infant morbidity and mortality such as inadequate prenatal nutrition and insufficient prenatal medical care. Though many American college fra-

ternities were founded as societies to promote literature and learning, they have, with the exception of the first, Phi Beta Kappa, almost entirely ceded this function to the educational institutions that shelter them, and they are now mainly defended by those who favor them for the social benefits that they provide their members both while they are college students and after. The Grand Army of the Republic, for obvious reasons, no longer exists.

In something like the same way, evolutionary biologists think of some organs as "exaptations"—organs whose present functions have accrued to them but whose existence is explained by their originally having evolved to serve different functions, as the human hand now functions to hold a writing instrument but did not evolve to serve that function. Heavy metal objects that once were used to press clothes are now useful only as doorstops, early large mainframe computers, I have heard it said, now would make only good boat moorings, and celluloid bustles, once standard items in women's wardrobes, now exist only in costume museums.

The fact that an institution may change its function over time is an instance of a general truth about artifacts to which one must be alert in attributing functions to them; if an institution has changed its function, then out presumption that what the designers of an institution say it is for is its artifactual function may be defeated.

Systemic Function of Institutions

Although my main reason for discussing the idea of a systemic function is to distinguish it from the idea of an artifactual function, and, more particularly, to distinguish the artifactual function claim about art, (F'), from the sort of functional claims more commonly made by social theorists about institutions and practices, it is worthwhile to spend a little time on this latter kind of claim.

I have suggested that the claims of a Marx or an Ortega seem best interpreted as attributions of systemic function, treating an institution or practice as a kind of "organ" of the social system with a specific role in maintaining its equilibrium in something like the way

the heart's pumping of blood helps to maintain the equilibrium of a living body.

An important difference between such claims and the biological claims on which they are modeled, however, is that it is not obvious that societies are organisms in the sense that animal bodies are or that they have organs whose functions can be determined in the way the function of the heart in animal bodies can. One part of the inference to the function of a part of a system is the determination that the alleged function is in fact what that part does. That the circulation of the blood is at least an effect of the pumping of the heart is straightforwardly determinable by noting that, in general, when a heart stops pumping, blood stops circulating. It is not so obvious, to take Ortega's claim as an example, that when the practice of art does not exist in a society (or, worse yet, if it were not to exist in a society), then the society, lacking a safety valve, explodes (would explode).

Suppose that this difficulty could be overcome. Beyond the claim that its function is something that an organ does, there is the further claim that its doing what it does is the explanation of why the organ exists. Even if it is granted that the effect of art is to provide a safety valve, it is not clear that there is anything like an evolutionary story available to underwrite the further claim that the explanation of the existence of art in society is that it does so. (Perhaps some combination of the ideas of cultural, as distinct from biological, evolution and of group, as opposed to individual, selection might aspire to do so, but they can hardly claim yet the status of classical accounts of, say, the biological evolution through natural selection of creatures with hearts.)

Latent Functions of Institutions

Social theorists, in attributing systemic functions to practices or institutions, typically see themselves as attributing latent, as opposed to manifest, functions (see, e.g., Robert Merton 1957). That is, they are concerned to insist that the function they attribute to some social practice is not necessarily (and, sometimes, perhaps, even necessar-

ily not) consciously espoused or even recognized by those who participate in that practice; it is no part of what an Ortega or a Marx wants to claim that the institutors designed the practice of art to serve the function they attribute to it or that its present practitioners endorse its serving that function.

Given that the function attributed is a systemic function, this is, of course, not surprising. One important point about systemic functions is that in general their presence is independent of anyone's beliefs or intentions about them. For the heart to have the systemic function of pumping blood it is not necessary for it or any part of it (or anything or anyone) to believe or intend that it have the relevant effect. Any distinction between latent and manifest functions in a case like this would seem to be otiose.

The reason the distinction is still worth making in cases of social systemic functions is that participants in social arrangements—people, as contrasted, for example, with bodily organs—often do have beliefs and intentions about the functions of those arrangements. Where there is a difference between what participants in social arrangements say those arrangements' functions are and what social theorists say they are, the distinction between latent and manifest functions enables the theorist to discount the difference. (This seems legitimate if the theorist's attitude is that she is interested in the dynamics of a social system as they operate quite apart from how participants in that system view it; it may be more dubious if her attitude is that she is interested in the *real* function of an arrangement as opposed to the erroneous and probably self-serving and self-deluded views of the function of that arrangement held by those who participate in it.)

Latent Systemic Functions versus Artifactual Functions in Institutions

What can we finally say in general about the relative standing of attributions of artifactual functions and of latent systemic functions to the same institution?

First, the claims that, to take a new example, the artifactual function of Oxford University is to supply a certain kind of education and

that its latent systemic function is to screen and certify prospective members of the British ruling elite seem to be compatible with one another. The implicit explanation in terms of the more-or-less conscious aims of the designers of the institution (or rather the shapers of it in its current form—we have here a notable example of institutional change) and the implicit explanation in terms of its contribution to the dynamics of British society may both be sustainable. Neither can reasonably purport to be a complete explanation.

There is, on the other hand, always the temptation lately noted to distrust the claims of the founders of institutions and thus regard the latent function as the real function. While one must recognize the epistemic difficulties of discerning the actual designs of the founders of institutions, there seems to be no general reason to distrust on principle their own considered and official statements, and thus no reason in general to think that the attribution of a latent systemic function to an institution somehow always trumps the attribution of an artifactual function to it.

Finally, we must face the question of the relative power of the explanations appealed to in attributing artifactual functions to institutions and the explanations appealed to in attributing latent systemic functions to them. The former are explanations appealing to extensions of folk psychology, the latter, to an analogy between society and living organisms. Let us suppose, then, that in their original homes they are equally powerful—that an explanation of the existence of the blade on my knife in terms of the thoughts of its designer and actions of its maker and an explanation of the existence of my heart in terms of the evolutionary value of circulating blood are equally good explanations.

Explanations of these kinds are extended in different ways in the cases under consideration. The folk-psychological explanation of an institution typically requires the extension of the idea of designs and actions to groups, involving the supposition of a "we" that shares in a project, but we are also, at least in the case of formal institutions, often in possession of ample evidence of what this "we" aimed to do and did. The former fact may raise difficulties of analysis, but there is no doubt that there is such a phenomenon (think of team sports), and the latter fact may provide some epistemic compensation. The

systemic explanation of an institution, on the other hand, requires us to extend the idea of a living system and its organs to society and its institutions and to suppose that there is some account of the systemic function of that institution in society as powerful as the biologist's account of the function of heart in the organism.

I hesitate to choose sides here, but where we seek to explain the existence of institutions, I am inclined to invest somewhat more faith in speculations about the thoughts and plans of their designers than in an appeal to the presumed contributions of presumed organs to the stability of a presumed system. Without denying the epistemic difficulties we often face in discovering, inferring, or surmising what people who lived long ago and of whom we know little planned or intended, I am inclined to be more confident that Oxford University was designed and modified by people with plans and intentions than I am that it is an organ with a specifiable role in maintaining the system that is British society in anything like the way in which the heart is an organ with a specifiable role in maintaining the integrity of its body.

Artifactual Functions of Informal Institutions

If we are satisfied that it makes sense to attribute artifactual functions to formal institutions and we are at least in some cases in an epistemic position to do so with some confidence, how does the situation stand when we turn our attention to practices and their associated informal institutions or worlds, in particular, the artworld and the practice of art?

The main problem may be put this way: It is not clear that there were individuals or groups of individuals who designed and made practices and their associated worlds in the sense in which there undoubtedly were individuals or groups of individuals who founded the Minneapolis College of Art and Design. It is plausible to attribute thoughts like "Let's start an institution to teach people how to be artists" to the founders of the Minneapolis College of Art and Design, and there are no doubt relevant documents that we could cite in evidence. It is also plausible to attribute thoughts like "I'm going to make something for people to sit on" to the designer and maker of an

early Colonial chair exhibited there. Even though we have no idea who that person was, we can be confident that there was such a person (or group of people) to the extent that we are confident that the object in question is an artifact, and we can be confident that he (or she or they) had some such thoughts to the extent that we are confident that it is a chair. But it seems difficult to imagine a scenario in which, for the first time, a poet, a painter, and a composer got together and said "You know, we're all artists, each in our own way; let's get together and start an artworld."

Surely, though, we can say at least this. There was a time, prior to the middle of the eighteenth century, when, even though people everywhere since time immemorial had engaged in aesthetic communication and people had for not quite so long engaged in such practices as painting, poetry, and music, there was no practice of art or artworld in the relevant sense. Then, not many decades later in Western Europe, some people engaged in these earlier practices had come to think of themselves and recognize others as engaged in a common enterprise—art—and come to value and to assert their identity as artists as well as their identity as painters, poets, or composers. The Western artworld and practice of art had come into existence, presumably as a result of the intentional actions of people, as it certainly has to this day continued to exist, to be maintained, and to be modified as a result of the intentional actions of its members. Yet it is much more plausible to think of a kind of welling-up and spreading of thoughts of common cause among many people in the already existing worlds of poetry, painting, music, etc., than of a Constitutional Convention of Founding Designers and Makers.

It might seem that this concession threatens to undercut the claim that the artworld is an artifact, or at least sufficiently analogous to an artifact for purposes of applying principle (AF), for that principle, speaking, as it does, of things "designed and made," seems to require that something to which it applies have designers and makers. Remember, though, that the concept of an artifact is really shorthand for the concept of something's having certain properties artifactually, and that this allows for what might be called degrees of artifactuality. A social arrangement, such as the artworld, which begins in some indistinct and inchoate way may soon become known, accepted, cher-

ished, and modified by those who recognize and value it—they may perhaps be regarded as the Modifiers and Maintainers, if not the Designers and Makers, of this arrangement.

If, granting the nonexistence of definite, even if unknown, original "artificers" of the artworld, we want to understand the function in the artifactual sense of the artworld, we have at least two lines of inquiry we can explore, even if we cannot speculate about the thoughts of any original designers and makers.

First we can try to understand what thoughts were extant, so to speak, at the time of the inchoate and indistinct beginning of the artworld. (Here is a perhaps surprising connection between something like Arthur Danto's 1964 conception of the artworld—"an atmosphere of artistic theory"—and the Dickiean conception of an informal "social institution" that I have adopted. By reflecting on the "atmosphere of theory" around the time of the emergence of the informal institution of the artworld, we may hope to discern about that institution something comparable to what we find out when we examine the designs and plans of the founders of formal institutions or of the makers of tools.) With this in mind, I shall look at some of what was said by Charles Batteux, Jean d'Alembert, and those who followed in articulating the concept of art in the mid-eighteenth century. What they said about art will provide a clue to what the earliest people to see themselves as members of the artworld thought it was for.

Second, we can reflect on what those who are now self-conscious maintainers (or would-be maintainers) of the now established informal institution of the artworld take it to be for. With this in mind, I shall look at some of what is said by those in marginal or recently recognized art forms, such as gardening, glass, fashion, and photography. What they think qualifies their practices as arts will provide a clue to the thoughts of those who are now members or would-be members of the artworld as to what that world is for.

The Next Step

In this chapter I have tried to clarify the artifactual concept of function invoked in thesis (F')—the thesis that the function of the art-

world and the practice of art is the promotion of aesthetic communication—just as in the two preceding chapters I tried to clarify the notions of aesthetic communication and of the artworld and the practice of art.

I have proposed principle (AF), that if something is good at doing something that it was designed and made to do, then doing that is its artifactual function, and I have argued that, even in the absence of identifiable designers and makers, we can hope to discover enough about the rise and subsequent history of the artworld to say what it was "designed and made" to do for purposes of applying (AF). I turn in Chapter 6 to the defense of the claims that the artworld is good at promoting aesthetic communication and that it can be regarded as having been designed and made to do so.

Art as an Aesthetic Practice

Art as Good at Promoting the Aesthetic

My first task in this chapter is to make plausible the claim that the artworld and practice of art is good at promoting aesthetic communication in the sense and to the degree required to apply principle (AF), that if something is good at doing what it was designed and made to do, then doing that is its artifactual function. I begin with some remarks about the relevant concept of goodness or value.

Value as Relative to Ends

The fact that the artworld and practice of art can be regarded as a human artifact permits us to treat the question of whether it is good at promoting the aesthetic as in important respects like the question of whether a particular worked piece of stone of a certain shape is good at cutting wood. In particular, the question is one of *instrumental*

value (value as a means) rather than value *in itself*, and it is a question of instrumental value for an antecedently specified end. So the sort of general skepticism about questions of value that hinges on its relativity to contingent and perhaps culturally parochial purposes has no purchase here.

It may be that a particular practice or institution is better at doing something in one culture than it is at doing that in another. (Arguably, for example, any medical tradition is better at promoting health where its authority is well established and there are no competing medical traditions than it is elsewhere.) But this is not a reason for skepticism about instrumental value, but only for care in taking account of facts that constrain its realization. In any case, the questions whether and when cutting wood or promoting the aesthetic are good things to do, though not to be ignored forever, are not relevant to inquiry about whether or not artifacts are good at doing these things.

Value as a Matter of Degree

If one is told that an artifact is good at doing something, the next question that springs to mind is *"How* good?" One need not be asking for a measure (say, 91 points out of 100), such as college teachers (perhaps less frequently than formerly) and wine tasters (undoubtedly more frequently than formerly) are sometimes expected to provide. But something on the order of "pretty good," "barely acceptable," "excellent," is surely appropriate. If someone responds to the question "How good?" by stubbornly just repeating "good" without further qualification, she or he is either saying something like "Pretty good; not excellent but better than barely acceptable" or does not understand the concept of value.

In the present context I shall argue only that one plausible answer to the question "How good is the artworld at promoting the aesthetic?" is something like "Good enough so that if it is that good at it and was designed and made to do it, then we can infer that that is its function."

Value as Comparative

Another response to being told that an artifact is good at doing something is to ask "Good compared with what?" The form of the answer is "Compared with the competition," which, of course, raises the question of what the competition is, both in the sense of what other artifacts the artifact in question is to be compared with at doing that and in the sense of what other things that artifact might do.

A Neolithic axe would not be all that good at chopping wood compared with what is available these days at Ace Hardware, and there are other things that it is likely to be better at, such as keeping papers on a desk from being blown away when the window is open. But that is not the competition when the question "Is this artifact good at cutting wood?" is being asked as part of an inquiry into its function. The competition is, in the first sense, other artifacts from the culture to which it belonged and, in the second sense, other things it might have been used for in that culture.

By the same token, when the question, asked in the course of an inquiry into the function of the artworld and the practice of art, is whether or not it is good at promoting the aesthetic, the competition is, in the first sense, other institutions and practices in the modern Western world that might plausibly be seen as promoters of the aesthetic and, in the second, other things that the artworld and the practice of art does or might do in the modern Western world.

Accordingly, my task is to compare the artworld with other contemporary Western institutions as promoters of the aesthetic and then to compare the promotion of the aesthetic with other things that the artworld does or might do.

The Artworld as Good Enough at Promoting the Aesthetic

Before proceeding to these comparisons, however, it is necessary to establish that the artworld is (sufficiently, but noncomparatively) good at promoting the aesthetic. An artifact might be better than the competition (in both senses) at doing something and still not be very good at it, in which case we would surely hesitate to say that it was

good at doing that in the sense and to the degree required to apply (AF). It is important, therefore, to observe that one thing that the art-world now does and does pretty well is, undeniably, to promote aesthetic communication. Without maintaining that it is some kind of conceptual truth or even contingently always the case that when an artist creates a work of art for an artistic audience he or she does so by designing and making something for someone to appreciate, it seems safe to say that this is frequently the way artists proceed. Frequently they fulfill their role in the artworld by making something intending that it shall afford appreciation and then making it available to others in a way and in such circumstances as to invite them to appreciate it. And in many such cases it seems apparent that genuine aesthetic communication takes place. (This seems to me to be so even though some artists may deny that they do or intend to do this and may deliberately try to frustrate aesthetic expectations as they understand them and despite the many features of the contemporary artworld—commercialization, social-climbing, conspicuous consumption, dumbing down, careerism, politicization—that interfere with aesthetic communication.)

It seems clear that the artworld is good enough at promoting the aesthetic that, if we can make plausible the two relevant comparative judgments—that it is better at promoting the aesthetic than competing institutions are and better at promoting the aesthetic than it is at other things it does—we will have sufficient reason to conclude that the artworld is good at promoting the aesthetic in the sense and to the degree required to apply principle (AF).

The Artworld as Better Than Other Institutions at Promoting the Aesthetic

Some other practices that are at least not obviously part of the art-world and that have some claim to be promoters of the aesthetic include government, business, religion, advertising, politics, industrial design, cookery, gardening, and nature appreciation. Is any of them as good as or better than the artworld at promoting the aesthetic?

Government and business. These institutions promote aesthetic

communication in various ways and to varying degrees—in Europe, for example, governments rather more than businesses; in the United States, the reverse—sometimes by subsidizing individual artists or commissioning or purchasing their work, more frequently by subsidizing formal institutions that are part of the artworld, such as museums, symphony orchestras, repertory theaters, and the like. (In a rather different vein, the Minnesota Humanities Commission for a time subsidized an institute for practicing journalistic critics of the arts.) These subsidies are undeniably important to their recipients, and without them the communities that benefit from them would be aesthetically the poorer, especially in light of the fact that some of these subsidies are in effect subsidies to audiences, reducing or eliminating the cost of attendance and thereby providing more appreciators.

Without minimizing the importance of these subsidies and, hence, of the institutions that provide them in promoting the aesthetic, such subsidies do not suggest the superiority of business and government to the artworld as promoters of the aesthetic. Quite the contrary, since they are subsidies to individuals and formal institutions in their roles as members of the artworld, they constitute, to the extent that they are aimed at promoting the aesthetic, very good evidence that the artworld is the primary promoter of the aesthetic and that business and government best serve whatever role they do in promoting the aesthetic by supporting the artworld, not by competing with it.

Religion, politics, and advertising. All of these practices certainly use aesthetic means for their own purposes. That is to say, people serving in roles as members of these institutions (and sometimes, though not always, simultaneously serving in roles as members of the artworld) sometimes produce artifacts with the aim (among other aims) that people appreciate them—find experiencing them valuable in itself.

(Remember that appreciation typically includes not only grasping, if not necessarily accepting, whatever "message" the artifact appreciated may express in virtue of its semantic or representational properties but also finding value in grasping that message as expressed. Appreciation is not simply a matter of grasping the message of what is appreciated—understanding, for example, that it represents the resurrection of Christ or that it is urging us to vote for Senator Wellstone

or to drink Coca-Cola—but neither is it restricted to noticing and enjoying the formal qualities of the way in which that message is presented. What is available for appreciation in artifacts with appropriate semantic or representational qualities is a particular content expressed in a particular way.)

Instances of aesthetic communication generated in the service of some message, then, are to be distinguished from merely didactic presentations, such that once one has understood them, one has no more need of them—one does not value experiencing them in itself, but only what one learns from the experience. They are also to be distinguished from such things as mass rallies, revival meetings, and attempts at brainwashing, which aim to move us to acceptance of some message or program of action by overwhelming our cognitive faculties. We do not value *experiencing* them, because, if they work, we do not experience them in the cognitive sense of what it is to experience something; rather they act on us as drugs might. Neither arguments for theses nor calls to action, then, typically afford appreciation, nor are they designed to do so.

Even with these qualifications firmly in mind, it still seems obvious that at least sometimes things made in the service of religion, politics, or commerce are designed to afford and do afford appreciation—the "Credo" of Bach's Mass in B Minor, the fourth movement of Shostakovich's Symphony no. 5, the advertisements from British television that are collected and shown annually at the Walker Art Center in Minneapolis.

This hardly makes religion, politics, and advertising reliable promoters of the aesthetic, however. One way of inducing belief or influencing action is to express a thesis or a directive in such a way that someone finds the experience of this expression of it to be valuable in itself. Such a person is not thereby given any reason, such as a good argument might give, to accept what is thus expressed, nor is she compelled to accept it, as she might be by a drug or a conditioning effect, but she is given a reason to repeat the experience and thus to encounter the message again in a context that is likely to be favorable to its reception.

There are, however, other ways of doing what religions, political movements, and advertising agencies are really up to; commission-

ing artifacts that afford appreciation is just one way among others that may be effective at persuading some of the people some of the time. The practices of religion, politics, and advertising promote the aesthetic only conditionally on its serving other purposes.

Furthermore, the instances of aesthetic communication these practices do support are determined by what they suppose will serve those further purposes and are thus likely to be of special kinds. (To change the example, military music may not be, as has been suggested, an oxymoron, but one would not like it to be all the music there was. People who deplore the fact—if it is a fact, and not just a myth of the sort that gives people something to be horrified about—that the amount of money spent on military bands in the United States exceeds the entire budget of the National Endowment for the Arts are perhaps in part responding to some such thought as this.)

A world that contained religion and politics but none of the components that make up our artworld—no world of music, world of painting, etc.—would doubtless not be totally bereft of aesthetic communication, but, supposing that an institutional structure benefits the activity it supports, it would surely be aesthetically impoverished. In general, institutions that use the aesthetic to achieve other ends are far from ideal as promoters of the aesthetic; they do not seem to be as good at promoting the aesthetic as is the artworld.

Industrial design, cooking, and gardening. Surely these practices involve aesthetic communication—people design and make chairs, dinners, and gardens with the aim and effect (among others things) that people appreciate them, where this may include not only finding looking at them valuable in itself, but also sitting in them, eating them, or walking in them, as may be appropriate.

Of course, their makers may also have other, perhaps overriding, aims—to provide seating or nutrition or to foster and improve plants. I have insisted that the fact that a Bach cantata or a Dürer altarpiece was intended as an adjunct to worship does not entail that it was not also intended to be appreciated (and that it can be appreciated not only if and when it has been relocated to the concert hall or to the museum but even as it serves its religious purpose). Something similar presumably can be said of a chair designed by Charles Eames, a tasting menu at Goodfellow's in Minneapolis, or Vita Sackville-West's gar-

den at Sissinghurst. Shall we say that the practices of furniture design, "gourmet" cooking, and serious gardening are the equal of art in promoting the aesthetic?

Perhaps the obvious response is to say that they, or at least some of their subpractices, are arts. Certainly furniture designers like Eames are recognized as artists in the way that architects are (indeed, furniture designers often are architects). Landscape gardening was recognized as an art in some of the lists of what constituted the fine arts during the eighteenth century. Such people as furniture maker Wendell Castle, wood-turner Mark Sfirri, and glass designer Dale Chihuly, have even largely abandoned the practical origins of their metiérs to make objects intended to be bought and sold on the art market and displayed in art museums.

An item a few years ago in the *Times* of London reported that the French Culture Ministry would give grants to enable promising young chefs to open their own restaurants, rather in the way that the National Endowment for the Arts in the United States sometimes subsidizes individual artists. In response, a French chef remarked, "At long last this is proof that we have passed from the status of workmen to that of creative artists." Apparently for him art is even more strongly institutional than it is in my view; an informal institution, such as I conceive the artworld to be, as contrasted with an official government agency, is evidently not for him sufficient to confer the status of art. But if the artworld as an informal institution has the power to confer this status and if, as I have also claimed, being recognized by authoritative members of the institution is not necessary for membership, it is that much easier to conclude that at least some parts of the practices of furniture design, cooking, gardening, glassblowing, wood-turning, and the like, are artistic practices and that some members of the associated worlds are members of the artworld.

Nature. Allen Carlson (2000) defends at length the view that the appreciation of nature, properly understood, involves cognitive elements in something like the way I have insisted that appreciation in general does. Does the practice—for such it surely is—of nature appreciation, or perhaps environmentalism, one aspect of which involves promoting the appreciation of nature, equal or surpass art as a promoter of the aesthetic?

The problem with this suggestion is not simply that an aspect of what I have called aesthetic communication—namely, someone making something—is, barring some kind of creationism, missing in nature, though this is certainly the case, and it is important for my argument. That argument, however, does not depend on taking the existence of a maker and an artifact, included along with an appreciator in the paradigm of aesthetic communication, as *essential* to the aesthetic. I am not really concerned to insist on necessary conditions for the aesthetic, and to the extent that I have gestured in that direction, I have taken appreciation, surely something that can be afforded by nature as well as artifacts, as the closest thing to a necessary condition.

The point, rather, is that, where what affords appreciation is some aspect of nature there will necessarily be missing any of the experienceable and hence appreciable qualities that artifacts have in virtue of their having been designed and made. These would include, for example, the kinds of expressive qualities that Guy Sircello (1972) associates with the "artistic acts" of a designer and maker—qualities such as wit, boldness, imaginativeness, and elegance, which, though detectable in the object, are there only in virtue of similar qualities in the actual acts of the designer and maker. No doubt the appreciation of nature has its own considerable rewards, but the absence of any maker of natural objects and their consequent lack of a range of qualities that may afford appreciation in artifacts, together with the fact that there is apparently no comparable lack in artifacts—no considerable range of appreciable qualities exemplifiable by nature but not by artifacts—suggests that the practice of nature appreciation is less efficacious than the practice of art at promoting the aesthetic. A world in which nature was appreciated but no artifacts were would be aesthetically impoverished in comparison with a world in which artifacts were appreciated but nature was not.

No doubt practices and institutions other than those I have discussed could be proposed as competitors with art as promoters of the aesthetic. My expectation would be that any such proposed competitor could be dealt with in one of the four ways with which I have dealt with the competitors I have discussed: either as (i) an institution that promotes the aesthetic by promoting art, (ii) an institution that pro-

motes the aesthetic by using it in pursuit of other more fundamental aims that it has, (iii) an institution that in promoting the aesthetic becomes part of the artworld, or (iv) an institution that promotes the aesthetic under limitations that do not apply to the artworld.

On the basis of such considerations, then, the claim that the artworld and the practice of art are better than possible competing informal institutions and practices at promoting aesthetic communication seems plausible.

The Artworld as Better at Promoting the Aesthetic Than at Doing Other Things

The artworld does many things other than promoting the aesthetic: it provides fame, wealth, power, or social status in various ways for some of its members; it facilitates the promotion of various religious, moral, political, or philosophical beliefs, attitudes, or behavior; it provides means for self-expression and fosters craftsmanship and creativity.

Fame, wealth, power, and social status. Undoubtedly some people's participation in various roles in the artworld is motivated at least in part by greed, the hunger for power, or the desire for fame or for social status. But the artworld is not very dependable at providing these benefits for its members; only a few of them acquire riches, power, fame, or social status. Indeed, providing some of these benefits to its members is something that many other institutions do incidentally and more or less unreliably for their members. Consider the academic world: a few, but only a few, academics achieve fame, wealth, power, or social status. So it seems to be in varying degrees with most such worlds. In no such case does it seem that the world in question is as good at providing these goods to its members as it is at whatever might for that world be comparable to promoting the aesthetic for the artworld. (There may be institutions and practices that really do have these aims and are to varying degrees successful in achieving them; investing is about money, politics about power, and "society" about status.)

The artworld clearly seems to be better at promoting the aesthetic

than at providing the benefits of wealth, fame, power, or social standing to its members.

Religion, politics, morality, and philosophy. Members of the artworld acting in their roles as artists, critics, patrons, and so on frequently see themselves as promoting some religious, political, moral, or philosophical agenda. Is it plausible to suggest that the artworld is better at doing these things than it is at promoting the aesthetic?

I observed above in this chapter that religious and political institutions may promote their own ends by supporting the artworld's promotion of the aesthetic, but this does not show that they are as good as the artworld at promoting the aesthetic. By the same token, the fact that members or parts of the artworld may use the aesthetic as a means of promoting religious, political, moral, or philosophical aims has no tendency to show that art is better at promoting religious, political, moral, or philosophical belief or behavior than it is at promoting the aesthetic. It is only in virtue of the aesthetic power of art that art as a practice and the artworld as an institution (or individual artists or formal artistic institutions acting in their roles as members of the artworld) can contribute to such goals; any such contribution is contingent on at least minimal aesthetic success. (There is no reason to suppose that the best artistic propaganda is the best aesthetically but equally no reason to suppose that there is an inverse relation between success at promoting some political or religious agenda and aesthetic success.)

An artist may sell a work and donate the proceeds to help construct affordable housing, or a museum might decide that rather than constructing an adjoining sculpture garden to foster appreciation among those who do not normally darken the doors of museums they would do better to build affordable housing on the lot. In either case (if we imagine that neither the artist nor the museum is very good) it might turn out that the artist or the museum was in fact better at helping to provide affordable housing than at promoting the aesthetic. But neither would be a case of a member or an institution acting in its role in the artworld, so neither has any tendency to show that the artworld or its members or parts are not, in the relevant way, better at promoting the aesthetic than they are at providing affordable housing.

The artworld clearly seems to be better at promoting the aesthetic than it is at promoting religious, political, moral, or philosophical beliefs, attitudes, or behavior.

Self-expression and creativity. Another, perhaps more plausible, candidate for something that art is better at than promoting the aesthetic is providing for self-expression and creativity. It is partly in recognition of the importance of such Romantic themes and their recognition—even glorification—of the artist that I have adopted aesthetic communication, rather than mere appreciation, as my paradigm of the aesthetic. Certainly, to the extent that the practice of art is good at promoting aesthetic communication it will be good at promoting creativity in artists—those who, in making things to be appreciated, also create works of art for an audience—and in so doing it will also promote self-expression, at least in the sense that many if not all of the works those artists create will be the upshot of artistic acts, in Sircello's (1972) sense, and at least in that way expressive of their artist-makers.

It is not clear, however, that art is all that good at promoting creativity and self-expression in any general way. There are kinds of creativity, such as those exhibited by scientists and (perhaps) philosophers, and of self-expression, such as those exhibited by competitive athletes and entrepreneurial businessmen, that seem not to be particularly fostered by art. The kind of creativity and self-expression fostered by art is, not surprisingly, if I am right, specifically the kind exhibited in the making of objects for appreciation.

Moreover, in something like the way that the appreciation of nature alone would give us a relatively impoverished appreciative life, even more so would creativity and self-expression without a public object designed to afford appreciation. Part of art's effectiveness in promoting the occurrence of aesthetic communication resides in its promoting the creativity and self-expression characteristically exhibited by artists, but this does not support the claim that art is better at fostering creativity and self-expression than it is at promoting aesthetic communication. Part of what makes the artworld as good as it is at promoting the aesthetic is its fostering of creativity and self-expression, but equally important parts are preserving and presenting

works of art and building and providing for appropriate audiences. Together they effectively constitute art's promotion of aesthetic communication.

After consideration of the claims of these other activities—providing benefits for its members, promoting various programs, fostering creativity and self-expression—it remains very plausible that the artworld is better at promoting the aesthetic than it is at other things it does or might do.

The Artworld as Designed and Made to Promote the Aesthetic

I have already noted the fundamental metaphysical difficulty with the thought that any particular person or persons might be the institutors of the artworld. Nonetheless, I argued in Chapter 4 that the "atmosphere of theory" in Western Europe at the time during which the artworld emerged around the middle of the eighteenth century provides us with evidence about how those who, at about that time and in that place, first began to recognize one another as artists thought about art. If they did not exactly "design and make" the artworld, they were among the first to enter into the web of mutual recognition that constitutes it, and I argued that, for purposes of applying principle (AF) to the artworld, how these early modifiers and maintainers of it regarded their common enterprise may legitimately do duty for what its designers and makers designed and made it for.

The relevant "atmosphere of theory" stems from Charles Batteux's *Les beaux arts réduits à un même principe,* published in 1746, which provided the conceptual resources for people to enter into the web of mutual recognition that constitutes the artworld as we now know it, and surprisingly soon afterward, according to Paul Kristeller, we find Denis Diderot, Jean d'Alembert, and Charles-Louis Montesquieu in the *Encyclopédie* of 1751–1757 "codify[ing] the system of the fine arts after and beyond Batteux and through its prestige and authority g[iving] it the widest possible currency all over Europe" (1998, 423).

Somewhat earlier, of course, Alexander Baumgarten had introduced into philosophy in Germany the term "aesthetics," at first defined as "the science of how things are to be cognized by means of the senses,"

but, according to Paul Guyer, conceived of in Baumgarten's later work as

> a study of the perfection of and pleasure in the exercise of sensibility for its own sake as manifested in the production of works of artistic beauty,

where beauty is conceived of as

> the perfection of cognition by means of the senses as such. (1998, 227)

Then, in the decades after 1760, again according to Kristeller,

> interest in the new field of aesthetics spread rapidly in Germany. Courses on aesthetics were offered at a number of universities after the example of Baumgarten [among others] . . . , and new tracts and textbooks . . . appeared almost every year. (1998, 426)

Baumgarten devoted most of his attention to poetry and did not himself seem to have a clear conception of the "fine arts" as Batteux, for instance, understood them, but with the publication of the Swiss Johann Georg Sulzer's dictionary *Allgemeine Theorie der schönen Künste* in 1771–1774 the idea of a general philosophy of the arts under the title of "aesthetics" was firmly wedded in the German-speaking intellectual world to a version of Batteux's grouping of the fine arts (Kristeller 1998, 426).

To the extent that the new conception of the fine arts came to be widely accepted, promulgated, and embodied in university curricula and other formal and informal arrangements, painters, poets, and composers were eventually largely persuaded to see themselves as engaged in different branches of the same business, and it is this, rather than the theory that inspired (and was perhaps was inspired by) it that really marks the emergence of the artworld. As Larry Shiner remarks:

> More important than treatises by Batteux and d'Alembert and dictionaries by . . . Sulzer [and others] were informal conversations at exhibitions, concerts, bookstores, and reading rooms, in French or Italian salons, British clubs, Dutch and German coffeehouses, and the many essays, reviews, and letters in the periodical press. (2001, 88)

It remains to argue that Batteux and the other writers just mentioned thought that the business all of these people were in was an aesthetic business. Even though at a relatively early time the modern concept of the arts and the new idea of the aesthetic were, as recently noted, already closely linked, things do not, so far as I am aware, work out quite so neatly as to yield any decisive quotations to the effect that the function of art is aesthetic. In any event, more important for my purpose than finding occurrences of the term "aesthetic" in appropriate contexts is showing that what these theoreticians said about what the fine arts had in common invokes recognizable precursors of the elements of what I have described as aesthetic communication—someone making something (i.e., bringing into existence a state of affairs) with the aim and effect that someone else appreciate it (i.e., find experiencing it to be valuable in itself).

As Shiner notes, the principle that, for Batteux and those who took up his scheme, justified

> uniting the visual, verbal, and musical arts under a single head yet also distinguish[ing] them from the other liberal arts as well as from the sciences and the crafts

was, first and most explicitly, the "imitation of Beautiful Nature," but Shiner also claims that

> at least four other principles were regularly invoked. Two of these principles—"genius" and "imagination"—concerned the production of works of fine art; the other two—"pleasure" versus "utility" and "taste"—concerned the aims and mode of reception of the beaux-arts. (2001, 82)

In making imitation central to art, Batteux was following at least two millennia of precedent provided by discussions of painting and poetry. I propose to abstract from this unsurprising feature, at which it is for us now easy to look askance, and concentrate on other aspects of his account.

First, whatever else an imitation of nature may or may not be, it is typically something *designed and made* by someone. (This seems true even of imitations in the sense in which stage "impressionists"

"do" imitations of well-known people.) The likeness of Winston Churchill traced by chance in the sand by Hilary Putnam's ant (Putnam 1981) is not an *imitation* of Winston Churchill. The first element of the paradigm of what I have called aesthetic communication is thus catered for by Batteux's formula.

Reflections on the making that characterizes the work of the artist would certainly lead most philosophers now to expand the category of making as exemplified by artistic creation to include the imitation of things other than nature and the making of things other than imitations, and some, reflecting on Batteux's "principles" mentioned by Shiner, of "genius" and "imagination," might be equally inclined to narrow it to exclude certain "mere" makings, not characterized by imaginativeness nor the products of genius. Though my account of the aesthetic is more responsive to the first of these impulses than to the second, it is important to remember (1) that it is not an account of art and (2) that my claim about art's function is compatible with the thought that not just any kind of aesthetic communication is worthy of being promoted or likely to be promoted by the institution of the artworld. In any case, it seems to me that the idea of someone making something provides a kind of minimal idea of (part of) the basic structure of aesthetic communication, an idea that may well be reasonably developed, qualified, and elaborated on in various ways, as indeed it has been in the recent history of aesthetics.

Further, however beauty may be understood, it is typically closely related to (if not—as, for example, famously by Thomas Aquinas— defined in terms of) that which, being seen, gives pleasure (*quae visa placent*). Here it is relevant to recall Guyer's account of Baumgarten's notion of the aesthetic as involving cognition by the senses and pleasure in the exercise of sensibility for its own sake and Shiner's attribution to Batteux of "principles" of "'pleasure' versus 'utility' and 'taste.'" In these sources we can see elements or anticipations of elements of the account of appreciation (i.e., finding the experiencing of a state of affairs to be valuable in itself) that provides the rest of my account of the structure of aesthetic communication.

In the context of the question of how the aesthetic in something like Baumgarten's sense might plausibly be regarded as the province of the fine arts in general, seeing is here first appropriately general-

ized to the other senses, and beyond that, I have maintained, must be generalized to experience in a sense that includes the grasping of meanings. (These generalizations may well be compatible with the sense of the Latin *videre*.) Further, though this experience is to be conceived of in cognitive (as opposed, say, to merely phenomenological or merely doxastic) terms, it is to be enjoyed for its own sake, in itself, not merely for the utility of the knowledge thereby gained of the object grasped. Finally, the introduction of the concept of taste suggests something more than "merely" enjoying or taking pleasure in this cognition, but something more like what I have tried to capture in speaking of finding value in the experience. (This thought, too, may be compatible with the sense of the Latin *placere*.)

In something like the same way that making imitations has come to seem too narrow an account of what artists do, *beauty* has come to seem too narrow an account of the value they strive to embody in what they make. In response to some such thought as this there appeared, especially in the latter part of the eighteenth century, an extensive literature on such concepts as the sublime and the picturesque, a literature that can be seen as a precursor of twentieth-century discussions of an indefinitely long list of what have come to be called aesthetic terms or concepts.

Finally, the idea of valuing an experience for its own sake, under a conception of "the principle of pleasure versus utility," in which these two values are not only distinguished but regarded as mutually exclusive, became transformed into detached, distanced, disinterested contemplation. This way of thinking of appreciation then underwrites what might be called The Myth of the Spellbound Spectator, according to which only such "pure" and extreme instances of appreciation really count.

Nevertheless, something like the fundamental thought that art typically involves making something to be appreciated, where appreciation is understood in general as I have explained it, seems to be discernible in the thoughts of these first theoreticians of art as we now conceive it, however much one or another of the basic elements of the picture may sometimes have been minimized or emphasized or attenuated or strengthened by them or by their successors. (At the least, there seems to be no reason to suppose that they thought of art

as being as intimately involved with any of the things other than promoting the aesthetic that it now does but which, I argued, it does not do as well as it promotes the aesthetic.) The atmosphere of theory from which the artworld emerged strongly supports the thought that its earliest members saw it as an aesthetic institution.

Another approach to the question of what the artworld is designed and made for is connected with the fact that institutions, like other artifacts, are subject to modification and decay. Whatever the designs and achievements of its earliest members, an institution's continuing success at doing what it was designed and made to do depends on its being *maintained* (or at least not subverted). If I am right, however, that as a matter of fact the artworld is still good at doing what it did when it originally emerged, evidently those who have maintained the artworld for its aesthetic efficacy have, so far, managed to hold off potential subverters (who are, of course, as anyone with any acquaintance with the artworld knows, prominent and forceful—it is no accident that there was published not too long ago a collection of essays by prominent critics and theoreticians entitled *The Anti-Aesthetic* [Foster 1983]). I say more in the Epilogue about those who might be described as thinking that the artworld ought not to make its primary business the promotion of the aesthetic.

Still, it is instructive to see what some maintainers or would-be maintainers of the artworld think of it as doing—those who have relatively recently joined or are attempting to secure their place in the artworld, in the sense that they are participants in practices whose status as artistic practices is, for whatever reasons, of fairly recent date (e.g., wood-turning, photography, glass art) or contested (e.g., cooking, fashion, gardening). One finds theoreticians of these practices giving reasons for their having been included or deserving to be included among the arts in the now well-understood sense—that is, for being added to some existing roster of the arts descended from Batteux's. Not surprisingly, these reasons typically take some such form as "We are in the same business as those practices already recognized as fine arts are," though they also often include qualifications designed to explain their late admission or contested status. In filling in the details both of the claims and the qualifications, these theoreticians tell us what they take the business of the fine arts to be and, by

implication, how they, as maintainers of the artworld they have happily joined or aspire to join, would presumably seek to maintain it. With striking frequency, what these would-be maintainers of the artworld say or assume is that their place in that world is a function of their own subpractice's aesthetic aims, so that we can, I think, fairly conclude that as maintainers of the artworld, they would try to preserve it as furthering those aims.

Examples can be found in such sources as exhibition catalogs and articles on the practices in question in the *Encyclopedia of Aesthetics* (Kelly 1998). For instance, the introduction to the catalog for an exhibition at the Minneapolis Institute of Arts in 2001 entitled "Wood Turning in North America Since 1930" talks of tracing this practice's transformation during this period into "a sophisticated art form," exploring

> new technical and aesthetic directions, viewing the lathe not as a limitation but as a challenge that elicits creativity, experimentation, and aesthetic accomplishment. (Minneapolis Institute of Arts 2001, 1)

Another theme that recurs in other claims of practices to the status of art based on their aesthetic aims is the tendency of some practitioners to produce works that do not even pretend to serve the nonaesthetic aims typically associated with the practice, such as Mark Sfirri's "Rejects from the Bat Factory" and other works of woodturners who

> consciously distance their creations from functional vessels, specifically fabricating objects for museum and gallery environments. (Minneapolis Institute of Arts 2001, 5)

(Though in my view such studied nonpracticality in its product is not necessary for communication to be aesthetic, any more than the deliberate aim of the maker to situate the product in the world of museums and galleries is necessary for it to be a work of art, no doubt the presence of these features supports reasonable presumptions that one is in the presence of the aesthetic in the first case and of art in the second.)

Early thoughts that photography might be regarded as a fine art ev-

idently labored under the handicap of Romantic presumptions about the artistic "creator" and contrasting views of photography as merely "mechanical," but in the late nineteenth century the view began to take hold that

> a photograph could be a work of art, irrespective of its genetics, if it occasioned "aesthetic pleasure" in the viewer. (Snyder 1998, 491)

(I take it that the phrase "irrespective of its genetics" in this context is not meant to imply that a photograph could be a work of art even if it were not something made by a human being. As with wood-turning, the making as well as the appreciating that are both part of aesthetic communication are at least implicitly catered for in saying what needs to be true of a practice and its products if it is to count as an art and they are to count as works of art. In general, it is typically taken for granted in such discussion as these that the practice in question involves people making things, and the issue about whether the things made are works of art tends to hinge on whether something like what I have called appreciation is intended or appropriate.)

Henry Frankel begins his encyclopedia article "Aesthetics of Glass" with the claim that

> since the 1960s, glass has become a medium for making serious works of art. . . . Workers in studio glass are artists, having learned how to exploit various properties of glass to produce works of significant artistic and aesthetic merit.

He concludes:

> Glass has tremendous aesthetic potential, a fact that is easily recognized once one examines works in glass without being confined by glass's long history as a medium for making pretty, solely functional, or highly decorative objects. (1998, 308)

It is not clear exactly what distinction Frankel may have in mind between artistic and aesthetic merit, but it is clear that for him the potential for aesthetic merit is crucial to the claim for artistic status. It is further clear and unsurprising that he distinguishes the aesthetic

from the solely functional, but perhaps somewhat more surprising that he distinguishes it from the pretty and the highly decorative as well. In his discussion of the well-known glass artist Dale Chihuly, he notes that his works

> are so sensuous . . . that some viewers classify them as pretty rather than beautiful,

but he goes on to insist that

> many of Chihuly's works are aesthetically beautiful, exhibiting an overall harmony in shape and color. Many . . . are about both the forces that shaped them and the light that often appears to radiate from them. . . . Chihuly is an Abstract Expressionist who has chosen glass as his medium of expression. (1998, 310–11)

Frankel, then, may have somewhat idiosyncratic ideas about the aesthetic, but his discussion clarifies that it is glass-making's ability to instantiate what would be generally recognized as aesthetic properties that makes it a medium of artistic expression.

Turning to contested or marginal arts, as contrasted with recently recognized arts (though this distinction may not itself be uncontestable), consider cooking. Elizabeth Telfer (1998, 208) defines a work of art (as I do not) as something intended (or appropriated) to evoke an "aesthetic reaction," which, where it is positive rather than negative, strongly resembles what I have called appreciation in that in simple cases it consists in "noninstrumental, vivid pleasure . . . in something as perceived by the senses," with possible difficulties noted in applying the definition to literature and complications recommended in generalizing from feeling pleasure to making a positive judgment. With these accounts of the aesthetic and art in place, she is able to make a credible case that dishes and meals can be intended or appropriated to evoke positive aesthetic reactions and that, on these grounds, they can be works of "food art" (though she concedes, that the art of food, lacking the power to represent the world in the way that literature and painting can and the power to express emotions in the way that music can, "must remain a minor art form" [1998, 210]).

In his encyclopedia article "Fashion as Art," Richard Martin more or less assumes that

> fashion . . . address[es] the aesthetic needs and expressions of the individual

but goes on to make much of its function as an indicator of social status and context more generally:

> One of the most vexing issues in considering fashion is its oscillation between the expressions of self and society, neither supreme in modern clothing's equivocation between an aesthetic objective and a cultural condition. (1998, 154)

He asks:

> Given its deep involvement in social workings, can fashion be considered a work of art?

and answers:

> Knowing that all works of art incubate in the social fabric as much as in inspiration alone, fashion is not solitary in being culturally engaged and thereby vitiated from a status as pure art. (1998, 156)

This defense of fashion as art thus takes it for granted that its status as art is a function of its aesthetic aims; it seeks to undercut the thought that threats to its "purity" from its "cultural engagement" and from its being deeply involved in commerce undermine its artistic status, on the grounds that these are but conditions of the canonically recognized arts in general.

Consider, finally, gardening, whose status as an art has perhaps been accepted (and, at the same time, contested) for longer than any of the other "marginal" arts just considered. Mara Miller's encyclopedia article "Gardens as Art" attempts to trace the sources of the tendency among modern philosophers to ignore, if not to denigrate, the claims of gardens to have the status of works of art. She traces this tendency first of all to

the general preferences that philosophers have shown for arts that privilege sight and sound over touch and smell, for arts that are devoted to one sense over *Gesamtkunstwerke* such as gardens, . . . for works that can be recognized in a single final form . . . as opposed to a form that changes constantly and even unpredictably over time . . . , [and for] works by single authors, which gardens rarely are.

She continues:

Surely the main reason gardens have been ignored by philosophers, however, is the utter discrepancy between the sources of aesthetic value in gardens and the principal notion(s) of aesthetics as it has developed during the modern period: aesthetic distance or disinterest and the "autonomy of the work of art." (Miller 1998, 274)

As she in effect suggests, the alleged prejudice of philosophers in favor of particular kinds of aesthetic communication ought not to prevent us from recognizing the different kinds in which gardens are typically ingredient. The extent to which taking a particular, extreme variety of appreciation as normative leads one to ignore the aesthetic claims of gardens is just one more measure of the inadequacy of the traditional view of distanced disinterested detached contemplation as necessary for appreciation.

Recognizing the claim of gardens to be art, then, mainly requires that we have an appropriately broad conception of the aesthetic. Given such a broad conception, it is easy to see that gardens have many of the standard aesthetic marks of art. As Miller says, "they have beautiful . . . qualities, they produce . . . aesthetic experience, they are the product of a forming human intention." Moreover, "they have often been considered art" (1998, 277).

Finally, Beardsley's traditionally aestheticist definition of art and the Dickiean institutional definition, which, though I have not wholly endorsed either, have, in different ways, been pervasive influences on my version of aestheticism, are, in Miller's view, both plainly satisfied by gardens:

Monroe Beardsley's generous principle—"What establishes an art kind, on my view, is that a good many of its individual instances are

created with the intention (perhaps among others) of making aesthetic experience attainable"—would clearly include gardens. Similarly, George Dickie's "institutional definition," according to which a work is a work of art if "some person or persons acting on behalf of a certain institution (the artworld)" designates it a "candidate for appreciation." (Miller 1998, 277)

It seems clear that for Miller gardens are art because they fulfill appropriate aesthetic criteria.

Although for the defenders of "marginal" arts just discussed the connection between art and the aesthetic is not necessarily of the contingent historical sort that I have defended, nor would they all be in full sympathy with my account of the aesthetic, their aspirations for their practices to be recognized as arts and their belief that what is crucial to those practices meriting that recognition is their aesthetic dimension makes it plausible to suppose that as members of the artworld they have (or would have) an interest in maintaining it as a distinctively aesthetic practice.

I conclude that there is sufficient reason to believe not only that the artworld as it originally emerged was thought of by its earliest members as a promoter of aesthetic communication but that it is being maintained to do so as well.

The Argument for (F')

In this chapter I have argued that (i) the artworld and practice of art is good at promoting aesthetic communication, in that it is not only effective at it but also better at it than competing institutions are and better at promoting aesthetic communication than it is at other tasks and (ii) the artworld and practice of art was designed and made to promote aesthetic communication, in the sense that it was so conceived by its earliest members and is now being so maintained. Adding these premises to

> (AF) If something is good at doing something that it was designed and made to do, then doing that is its (artifactual) function,

it follows that

> (F') The function of the artworld and the practice of art is to
> promote aesthetic communication.

Intuitions and Objections Revisited

At the beginning of this book I characterized what I called "tradi-
tional aestheticism" (Chapter 1) as comprising two necessary and suf-
ficient condition claims,

> (F) Something is a work of art if and only if its function is to
> afford aesthetic experience,

and

> (V) A work of art is a good work of art if and only if it has the
> capacity to afford aesthetic experience.

I gave a number of objections to traditional aestheticism and a num-
ber of intuitions that supported it, and in Chapter 2 I offered my own
version of aestheticism, comprising theses (F'), above, and

> (V') A work of art is a good work of art to the extent that it
> has the capacity to afford appreciation,

with the aim of speaking to the intuitions while avoiding the objec-
tions. Now is a good time to see how this has played out so far.

I summarized the objections to traditional aestheticism in Chapter
1 as follows:

> Art has no essence. Even if it does, that essence is to be defined pro-
> cedurally rather than functionally. Even if a functional definition is
> not to be ruled out a priori, the alleged characteristically aesthetic
> state of mind or experience appealed to in traditional aestheticism's
> functional definition is bogus. Even if that state is not bogus, the ac-
> count of it as an experience brings with it unacceptably formalistic

views of the understanding of art and of the distinction between the artistically relevant and the artistically irrelevant. Even if it doesn't do that, the emphasis on the provision of aesthetic experience ignores what might be called antiaesthetic art (Duchamp) and hyperaesthetic art (Brecht). Finally, even if traditional aestheticism can accommodate these kinds of art, its emphasis on the audience involves a systematic slighting of the role of the creative artist.

How does the new aestheticism deal with these objections? First, thesis (F') makes no essentialist claim about art. Further, my account of the practice of art and the informal institution of art, to the extent that it at least involves general claims about art, embraces the historicism and institutionalism that typically lie behind procedural definitions.

Next, my account of aesthetic communication does invoke the "state of mind" that I call appreciation, but there is no reason to suppose that this state is bogus (in the way that there may indeed be reason to suspect the credentials of some of its relatives, such as distancing and the like.) Further, the account of experience I invoke in unpacking the idea of appreciation is sufficiently rich that, when it is invoked to distinguish between the artistically relevant and the artistically irrelevant, it comfortably encompasses semantic and expressive properties as well as strictly formal ones. For the same reason, it can give sympathetic accounts of how allegedly antiaesthetic and hyperaesthetic works of art can enter into what I call aesthetic communication. Finally, the inclusion of the maker in the paradigm of aesthetic communication blunts the force of the objection that aestheticism is bound to be excessively spectator-oriented.

I summarized the intuitions supporting traditional aestheticism thus:

> Traditional aestheticism accounts for the clear and strong connection between art and the aesthetic; explains why experiencing a work of art is crucial for understanding and appreciating it; underwrites a criterion for distinguishing between those properties of works of art that are relevant and those that are irrelevant for appreciating them as works of art; and, on the basis of its account of the nature of art, provides a principle of value in art.

How does the new aestheticism honor these intuitions? Thesis (F')
asserts a strong claim between art and the aesthetic. My account of
appreciation, embedded in the account of aesthetic communication,
requires that what is appreciated be experienced and thereby supports
a distinction between what is relevant and what is irrelevant for the
appreciation of works of art in terms of which of their properties are
experienceable and which are not.

To invoke (F') in support of (V'), while not exactly an argument for
a principle of value on the basis of an account of the nature of art,
surely would honor the spirit of the last intuition cited above, where
that intuition is stated in such a way as not to assume an essentialist
functional definition either of art or of a work of art. The argument
for (V') on the basis of (F'), then, is the main task remaining, and to it
I now turn.

Artistic Value as Aesthetic

Aestheticism and the Value of Works of Art

As I noted earlier, if one accepts traditional aestheticism's functional definition of a work of art,

> (F) Something is a work of art if and only if its function is to afford aesthetic experience

then the inference to an aestheticist principle regarding the value of works of art, namely,

> (V) A work of art is a good work of art if and only if it has the capacity to afford aesthetic experience,

is straightforward. Something like the following principle connecting function and value seems very plausible (and, incidentally, seems to apply not only to artifactual functions but to other kinds of functions as well—at least to the systemic functions attributed to bodily organs):

(FV) If something is a thing of a certain kind if and only if it
has a certain function, then it is a good thing of that
kind if and only if it has the capacity to fulfill that
function.

Accordingly, we might judge the main blade of a Swiss Army knife to
be a good blade if and only if it has the capacity to cut.

As true—even truistic—as it may be, however, (FV) is of no direct
use to someone who argues for (F′), the claim that the function of the
practice of art is aesthetic, but at the same time concedes that it is
not the case that the function of each work of art is aesthetic—(F) is
not only not an adequate definition of art, it is not even true. Indeed,
there seems in general to be no route from a claim that a practice has
a certain function to the claim that things produced by its practi-
tioners have that very same function. Moreover, given, instead of (F),

(F′) The function of the artworld and the practice of art is to
promote aesthetic communication,

nothing follows from it and (FV) about what makes works of art good.
What we need in order to support the aestheticist criterion of the
value of works of art suggested earlier,

(V′) A work of art is a good work of art to the extent that it
has the capacity to afford appreciation,

is a principle that somehow, so to speak, "distributes" the function
of a practice and its associated institution onto its practitioners, their
actions when they are acting in their institutional roles, and, most
particularly for present purposes, the products of those actions.

Institutional Functions, Roles, and Products

Consider again formal institutions—for instance, the Minnesota
Humanities Commission, one of the state humanities councils that
was brought into being, and initially wholly supported, by the Na-
tional Endowment for the Humanities in the early 1970s. The Min-
nesota Humanities Commission bills itself as

the only organization dedicated solely to supporting and promoting excellent humanities education throughout Minnesota,

and goes on to say,

Our programs are designed to ensure that the humanities are an integral part of lifelong education and public life for all Minnesotans.

There are obviously other institutions in Minnesota that support and promote excellent humanities education—notably universities and colleges—but not solely education in the humanities, and not necessarily throughout Minnesota, nor solely (or, in some cases, even primarily) for Minnesotans. Moreover, these institutions typically do not primarily provide lifelong education, but rather education for young adults, nor is their concern primarily with humanities education as it may contribute to public life or as presented to a general public, but rather as it enhances the lives specifically of those who apply and are admitted to study at them. So the Minnesota Humanities Commission's function, as more-or-less officially stated by its sustainers and shapers (the quotations are from its Web site, not necessarily its constitution, and I allow for some changes over time in how the mission of this thirty-or-so-year-old institution's function has been conceived) is, in effect, to promote education in the humanities for those who typically are not served by such traditional institutions as colleges and universities and with an emphasis on a particular kind of benefit to "public life" that at least some kinds of education in some of the humanities may aspire to provide.

How might such an institutional purpose be distributed onto its members, their actions in their roles, and the products of those actions? Many different people serve in many different roles as participants in this institution—members of the board, the president, program officers, fund-raisers, lobbyists, presenters of public programs or workshops for teachers, editors of publications, public relations officers, managers of facilities, business and financial officers. These different people bring a variety of knowledge and skills to their many roles, and to that extent they will be judged as better or worse by different criteria—a good program presenter will not necessarily be a good financial officer, and vice versa. But in another way, what

any of them does in his or her institutional role is to be evaluated according to just one criterion: Does it help the institution to perform its function in the way that someone acting in that role is supposed to do?

In particular, the actions of some of the members of the institution are supposed to eventuate in products of one sort or another. The primary products of the Minnesota Humanities Commission were originally humanities programs emphasizing the relation of the humanities to issues of public policy (e.g., programs in medical ethics that discussed such issues as fairness in the distribution of medical resources). More recently its products have included literacy programs, programs aimed at older people, edited volumes and other materials intended for use in the schools, and programs for public school teachers. These products might have various benefits and virtues—for example, some may display original scholarship by their producers or provide a modest stipend for them; or they may attract favorable attention to the work of the Commission; or they may provide a means whereby members of their direct audience can better themselves economically, either by getting jobs that require a particular degree of literacy or by gaining credentials that will increase their income.

Again, however, the overriding criterion according to which they are to be evaluated as products of people occupying roles in the institution is the extent to which they help the institution perform its function in the particular way that the products of people in those roles aim to do so. Do the literacy programs promote the study of the humanities by helping to provide a fundamental skill necessary for such study to those who lack it and would not otherwise have an opportunity to attain it? Do the programs for teachers promote the study of the humanities by immersing the teachers, who have an opportunity and responsibility to present the humanities to K-12 students, in a serious study of the humanities in a way and to a degree that is otherwise unavailable to them? Do the curricular materials promote the study of the humanities by providing important and accessible humanities "content" that is otherwise not available to be taught to students who might not otherwise encounter the humanities?

People acting in other roles also generate products—memos, publicity materials, testimony before committees of the state legislature,

presentations to foundations, minutes of meetings, annual reports, and so on. For any of these products, the answer to the question of how good it is is both tied to its contribution to the overarching function of promoting humanities education and relative to the kind of thing it is as a product of someone acting in a particular role in the institution. Good memos from the president of the Commission to staff members or board members promote education in the humanities by moving people to fulfill their own proper roles in the institution; good presentations to foundations, by moving other institutions to support the Commission's efforts; good publicity materials, by bringing the Commission to the favorable attention of those in a position to support it, and so on.

Memos, publicity materials, reports, and the like are not, of course, the Commission's primary products. It would be a strange coincidence if, for instance, the text of one of them were to be proposed as a part of a curricular package for K-12 humanities study or as something to be studied in a teachers' institute; they make their contributions in other ways, appropriate to the roles of their producers in helping the institution to perform its function. (Correspondingly, that a particular curricular package attracts the favorable attention of, let us say, a legislative committee and thus contributes to the promotion of education in the humanities by helping the Commission to get a larger appropriation from the state legislature does not make it a good curricular package.) How good something is that is produced by a member of an institution acting in his or her institutional role is a function not merely of the contribution that thing makes to the functioning of the institution; it is good more specifically as such a product to the extent that it contributes to the institution's fulfilling its function in a way appropriate to the role of its producer.

Evaluating Institutional Products

Let me, then, on the basis of this example, venture to propose a general principle about the relation between the function of an institution and the criterion of evaluation appropriate to the products of those acting in roles within that institution—call it (FV').

(FV') If an institution has a certain function, then something produced by someone acting in his or her role in that institution is good as a thing of the kind thus produced to the extent that it has the capacity to contribute to the function of that institution in the way appropriate to it as a thing of that kind.

Some variation or generalization of this principle could probably be formulated and defended not only for products but for anything done by any participant in an institution acting in his or her institutional role; the general point is that the function of an institution and the existence of roles within it generate at least a prima facie criterion for evaluating what people acting in those roles do. More generally still, there is probably a plausible principle licensing the inference from any complex entity's function to criteria of value for its components as determined by their specific contributions to the fulfillment of its function; the even more general point here is that the function of any complex entity that has a function generates at least a prima facie criterion for evaluating its components. My concern here, however, is only with the inference from the function specifically of an institution to a criterion of value specifically for what is produced by people acting in their roles in that institution.

I offer no demonstration of (FV'), but I do think that, if properly understood and carefully applied, it is intuitively appealing both as offering a route from facts about institutions to principles for the (at least prima facie) evaluation of their products and also as not vulnerable, so far as I can see, to obvious counterexamples.

Works of Art as Produced by Artists and Affording Appreciation

If we are to invoke (FV'), along with the main thesis of this book,

(F') The function of the artworld and practice of art is to promote aesthetic communication,

as part of an argument for

(V′) A work of art is a good work of art to the extent that it
has the capacity to afford appreciation,

it will be necessary to defend appropriate claims about the kind of
things works of art are and about their capacity to contribute to aes-
thetic communication. The claims in question seem to me straight-
forward in light of what I have already said about art and the aesthetic.

First, given the thoroughly institutional account of art (as con-
trasted with the aesthetic) that I have given, it is a straightforward
consequence that works of art are only produced within the context
of an artworld in the broad sense in which I have been using that term.
Furthermore, those who produce works of art are artists; it is their
role in that institution to produce them. Anyone who produces a
work of art is acting in the role of an artist and is, to that extent, an
artist. Conversely, anything an artist produces acting in his or her in-
stitutional role is a work of art. Remember, of course, that not all
artists live in lower Manhattan nor does anything prevent artists from
occupying other roles in the artworld—critic, say, or teacher—or peo-
ple who primarily occupy other roles in the artworld from also occu-
pying the role of artist. Nor have I claimed that someone must be
recognized, formally or informally, by the artworld or even think of
herself or himself as an artist, in order to be an artist; my claim has
been only that someone at sometime must think of a person as an
artist or certain of his or her products as works of art in order for that
person to be an artist or those products to be works of art.

It seems to me, therefore, that we can plausibly accept the follow-
ing claim about what kind of thing, in the relevant sense, a work of
art is:

(K) What is produced by an artist acting in his or her role in
the artworld is a work of art.

(Note that this claim does not contravene any reasonable antiessen-
tialist scruples about the concept of a work of art; it does not purport
to be, in any interesting sense, an analysis of the concept of art.)

Next, as regards the contribution that works of art make to aes-

thetic communication, the account I have given of such communication—someone designing and making something with the aim and effect that it be appreciated by someone else—seems clearly to invite the thought that the distinctive contribution works of art are capable of making to such communication arises from their capacity to afford appreciation. (This is consistent with the thought that not all works of art are in fact made to afford appreciation, nor do they all in fact afford appreciation.) Accordingly, the following principle, stating the contribution of works of art to fulfilling what I have argued is the function of the artworld, seems plausible as well:

(C) A work of art has the capacity to contribute to aesthetic communication in the way appropriate to it as a work of art to the extent that it has the capacity to afford appreciation.

The Argument Summarized

We can now gather the premises of the argument in one place:

(FV′) If an institution has a certain function, then something produced by someone acting in his or her role in that institution is good as a thing of the kind thus produced to the extent that it has the capacity to contribute to the function of that institution in the way appropriate to it as a thing of that kind.

(F′) The function of the artworld and practice of art is to promote aesthetic communication.

(K) What is produced by an artist acting in his or her role in the artworld is a work of art.

(C) A work of art has the capacity to contribute to the promotion of aesthetic communication in the way appropriate to it as a work of art to the extent that it has the capacity to afford appreciation.

We can then instantiate (FV′), taking the artworld as the institution in question, the promotion of aesthetic communication as the func-

tion, works of art as the things produced, producing them as the role of artists in the artworld, and affording appreciation as their appropriate contribution as works of art to that function. Finally, from the resulting instantiation together with (F'), (K), and (C), there follows the desired conclusion:

> (V') A work of art is a good work of art to the extent that it
> has the capacity to afford appreciation.

I do not mean to suggest that this argument is anything like a demonstration in the full Aristotelian sense, such that it must somehow compel any rational person to acquiesce in its conclusion. I do claim, however, that it is a valid argument, such that anyone who accepts its premises is logically committed to its conclusion, and I have tried to show how each of the premises is plausible. (Some time after developing this argument, I was struck by its affinity with John Searle's attempt to derive an "ought" from an "is" (1964); it certainly seems that the conclusion is "evaluative" in a way that none of the premises apparently is, and, as with Searle's argument, a crucial part of the strategy is to invoke obligations imposed by participation in a practice.)

In light of the connection I have made between the concept of appreciation and the notion of aesthetic communication, the conclusion of this argument, principle (V'), is reasonably describable as an aesthetic account of artistic value.

What (V') Does Not Imply

It is important to be clear about what (V') does and does not imply—most important, it does not imply what might be regarded as the excesses of some forms of aestheticism.

Recall first from Chapter 3 that the account of appreciation being appealed to does not imply that only formal and/or sensible qualities of works of art can afford appreciation; hence, the qualities of a work of art that make it a good work of art given (V') are not correspondingly restricted to formal and/or sensible qualities.

Independently of this, notice that (V') does not imply that aesthetic values trump all other values. This is a claim that some artists or philosophers marching under the banner of some kind of aestheticism have made, but it is no part of my argument. I am inclined to regard the values exemplified in works of art that afford appreciation and realized in aesthetic communication as among those fundamental to human flourishing, and that is perhaps to rate them more highly than many do, but it is not to grant them pride of place among values in general. I do not have so much as the beginning of a theory about what all the values fundamental to human flourishing are and how they are to be ranked in order of precedence when, as is unfortunately likely to be the case, they conflict. I am prepared, however, to grant that it is not the case that the values realized in aesthetic communication are in some general way the values that should take precedence when they conflict with others, and it should be clear that claiming that the criteria for evaluating a work of art as a work of art are aesthetic does not commit one to any view to the contrary.

By the same token, claiming that the criteria for evaluating a work of art as a work of art are aesthetic does not imply that there are not other criteria by which works of art may appropriately be evaluated, for a work of art may simultaneously be a thing of many other kinds—an expression of a moral vision, say, or a political gesture, or an advertisement, or a piece of propaganda, or a philosophical argument, or an offering to God, or a technical experiment, or part of a career-enhancing strategy, or an investment, or a bit of interior decoration. When a work of art thus is something in addition to being a work of art, it is appropriate, in addition to evaluating it as a work of art, to evaluate it also as what, other than a work of art, it is.

There may or may not be reason to think that something's being good as a work of art has some connection—either positive or negative—with its being good as one of these other things; there are many different questions here, and there is no reason to suppose that all of them will have the same answer. There seems to be no reason to suppose, for example, that, in works of art that are also philosophical arguments (some Platonic dialogues, perhaps, or Lucretius's poem "De rerum natura," or Alexander Pope's *Essay on Criticism*), there is any strong correlation one way or the other between their value as literary work of arts and value as philosophical arguments. On the other

hand, it might be argued, especially if appreciation is thought of in the relatively rich and conceptually loaded way in which I have explained it, that moral failings are likely to have a negative impact on the capacity of a work of art to afford appreciation (consider Leni Riefenstahl's glorification of Hitler, the documentary film *Triumph of the Will*). Or again, it might be urged that the capacity to afford appreciation enhances the value of a work of art as an aid to or aspect of religious worship.

Here again, if we imagine cases where something is very good as a work of art when judged in accordance with criterion (V') and not very good, say, as an advertisement or a piece of interior decoration, or cases where a work of art is an effective piece of propaganda but not very good as a work of art when judged by criterion (V'), there does not seem any reason to suppose in general that the value of the thing as a whole—as all the kinds of thing it is—is exclusively or primarily determined by its value as a work of art (or, indeed, by its value as one of the other kinds of things it is). Indeed, it is not even clear that much sense can be given to the question: How good overall is it, considered as all the kinds of things it is?

That criteria of value are relative to kinds and that a thing can be of more than one kind are facts that stand in the way of any easy general answer to questions about the weighting of conflicting values, but the defense of the claim that the value of works of art as works of art is aesthetic does not require that there be any such easy general answer, let alone that the answer must favor aesthetic values over others.

Applying (V')

Another set of issues concerns how the general principle (V') might be combined with other premises to yield a judgment of the value of a particular work of art as a work of art. What do we need to have, along with

> (V') A work of art is a good work of art to the extent that it
> has the capacity to afford appreciation,

to justify a claim that a particular work of art is a good work of art?

To ask this question is to ask for something like a full-scale theory of artistic evaluation, and that is not something that I aspire to provide here, but something can be said by way of suggesting the questions that such a theory would have to face.

First, the centrality of the concept of appreciation in principle (V') invites the question, "Whose appreciation?" Is the capacity in question that of affording appreciation to anybody who encounters the work, or rather to anybody who is minimally acquainted with works of broadly similar genre and style, or rather to the cognoscenti? Surely the relatively rich epistemic conception of appreciation being invoked here implies that at least some features of works that can afford appreciation to the cognoscenti will be inaccessible to others who encounter the work. Any attempt to apply this principle to particular works of art would involve deciding whose appreciation would count toward establishing that a particular work does indeed have the relevant capacity.

Further, since the principle evidently relates the "extent" to which a work of art has the relevant capacity to its goodness as a work of art, it involves the very plausible assumption that the goodness of works of art comes in degrees—works can be more or less good. This invites us to propose some sort of scale for grading works of art, as well as to defend an account of how good they have to be to count as (really?) good, as a condition of being in a position to defend an assessment of a given work of art as having the capacity to afford appreciation to the extent necessary to justify judging it to be a good work of art.

Finally, reflection on the present concepts of appreciation and of aesthetic communication suggests that neither all acts of appreciation nor all instances of aesthetic communication are created equal. Some things are easy to appreciate and some things that have the capacity to be appreciated are easy to make. My initial paradigm of aesthetic communication was deliberately a simple and straightforward one—someone shaping and smoothing a piece of stone and showing it to someone else to admire. Any theory of what makes a work of art good or one work of art better than another would ultimately have to say something about this issue, reminiscent of—perhaps ultimately the same as—the question of the relative merits of the pleasures of pushpin and the pleasures of poetry discussed by the early Utilitarians.

It is a fair comment on the present account of the function of the artworld and the practice of art that nothing I have yet said helps us to understand the dynamics of that institution, in particular the impulse both for artists to refine the skills and advance the frontiers of their art and for dedicated artistic audiences to seek ever more subtle objects of appreciation. In short, nothing is said about its drive to increase what might be called the *richness* of aesthetic communication, and how that might play out in judgments of the value of individual works of art according to principle (V'). But neither does anything in the account seem to stand in the way of a full recognition of the importance of these issues and the pursuit of a deeper understanding of them.

Perhaps we can agree that an acceptable theory of the structure of reasoning about the value of individual works of art that incorporates an aesthetic account of artistic value such as (V') is difficult to envisage, but it seems to be no more difficult to envisage than any such theory, whatever principle or principles of artistic value it may countenance instead of or along side of principle (V'). This problem is not a problem about the new aestheticist principle of value in particular, but about any attempt to understand how general principles and particular judgments interact in our thinking about values.

The Significance of the Aesthetic Account of Artistic Value

What, then, do we get from (V') in its present state, supposing that the argument for it is successful?

At least we can say that a necessary condition of a work of art's being any good at all as a work of art is that it have some capacity to afford some appreciation to somebody; that no other capacities or virtues it might have, of whatever nature and however considerable they may be, are directly relevant to its value as a work of art; and that the information relevant to deciding how good a work of art is as a work of art or whether one work is better than another as a work of art is information about the capacities of this work or these works to afford appreciation to somebody. We might wish for more, but if even these claims are true, many antiaestheticist views that have at various times been popular among artists and theorists of art are false.

Epilogue: The End of Art?

The Contingency of the Aesthetic Function of Art

The argument for (V'), the claim that a work of art is a good work of art to the extent that it has the capacity to afford appreciation, crucially depends, of course, on (F'), the claim that the function of the artworld and the practice of art is to promote aesthetic communication, and I have admitted, even insisted, that this central claim is a matter of contingent fact rather than a matter of necessity or definition.

Nor is this merely a matter of metaphysical or epistemological interest; given that practices and institutions—formal and informal—come into existence, change and adapt, decline and die, nothing assures us that the artworld will continue to exist or that, if it does, the practice of art will continue to pursue the end that it has pursued and still does pursue. The practice of art as it presently exists might end, either in the sense that it will cease to exist or in the sense that its practitioners will cease to see themselves as primarily pursuing aesthetic ends. This would be a rather different "end of art" from that fa-

mously announced by Arthur Danto (1986), in which art, having through the dialectical unfolding of its history achieved a kind of philosophical self-understanding, has completed its task. Rather it would be akin to the end of art as described and deplored by Donald Kuspit, in which art "becomes simply another sample of visual and material culture, losing its privileged position as a source of aesthetic experience" (2004, 10).

The Contestability of the Aesthetic Function of Art

Nor is the death of art in this sense a mere abstract possibility. Indeed, in Kuspit's view it is at least imminent and may even already have happened. That art is in fact an aesthetic practice is far from universally accepted within the artworld; more to the point, many voices both within the artworld and outside it can he heard urging that, even if it is, it should not necessarily continue to be so—that art, rather than merely providing "aesthetic highs" or "eye candy" for the wealthy, should serve higher or contrary moral or political ends. Moreover, even though—given that the "aesthetic state of mind" is conceived, as I have urged, in such a way as to encompass the appreciation of meaning while not being restricted to its most rarified instances—it is not as easy as it might at first seem to be to envisage art as genuinely rejecting its aesthetic function, there is no doubt that, as amply documented by Kuspit, the rhetoric and practice of many disenchanted members and observers of the artworld seems to urge some such outcome.

The possibility that members of a world may cease to identify with what that world does means that the application of any thesis that, like (FV'), licenses inferences from the function of an institution or practice to principles for evaluating its products—or, more generally, for evaluating the actions of its members as participating in their institutional roles—will at best yield principles that bind those members conditionally on their acceptance of that function. Typically members of a world are or at least once were in broad agreement about the function of the practice in which they are engaged; if it were not so, it is hard to see how a practice and its world could have come to

exist. But nothing makes it impossible for some members of a world to grow disenchanted with what the informal institution they have joined does, to the extent that they no longer want to participate in promoting it; and so it might be that some artists might decide that they no longer want to participate in promoting aesthetic communication by making things for appreciation.

One response by such members of the artworld at this point would be to drop out. Certainly in general no one has any unconditional obligations to continue to participate in a practice with whose aims she or he is no longer in sympathy. (Perhaps not all informal institutions are staffed by volunteers, but the artworld largely is.) Supposing that no very large number of important participants thus abandon the artworld, this would not be any apocalyptic end of art; it would just be the end of a few artists.

A more radical response, of course, is what might be called subversion—continuing to participate in the artworld but trying to persuade it to adopt a different end. The rhetoric and the practice of many modernist and postmodernist movements in the arts often seem not only to call art to serve ends beyond the aesthetic but systematically to reject many of the values, such as beauty and craftsmanship, traditionally associated with the aesthetic. At the same time, members of the artworld who are unhappy with such tendencies can be found vigorously promoting and defending movements and even founding formal institutions designed to counteract, or at least provide an alternative to, antiaestheticism. (The American Society for Classical Realism, for instance, founded in Minneapolis in 1989, says that its goal is "to further those values and ideals associated with the finest achievements in the art of painting, drawing, sculpture, and print-making of the past.") Even someone who deplores a change in an institution's function—perhaps especially such a person—recognizes that such change is possible and must surely realize that no appeal to the presumed "nature" of the institution can by itself prevent such change.

The aesthetic function of art is thus not only contingent but also contestable and is in fact being contested. What, then, if art were to end, in the specific sense that the informal institution and practice should cease to have the aesthetic function I have attributed to it?

The Persistence of Aesthetic Communication
and the Revival of Art

Aesthetic communication, as I have described it, seems to have occurred in prehistoric times and to occur now in many different cultures. I have insisted that it in no way depends for its existence on the artworld or the practice of art. It seems plausible to suppose that making things to be appreciated by others is a fundamental human impulse.

If this is the case, the demise of the artworld as an institution promoting aesthetic communication might be unfortunate, but it would hardly be the disaster that the phrase "the end of art" (in one of its meanings) might suggest. (Nor, of course, is the end of art in Danto's [1986] sense necessarily such a disaster, though for different reasons.) It would be unfortunate to the extent that a complicated cooperative arrangement of people and formal institutions that was designed to subserve and has subserved a fundamental human need would no longer do so. People who had become part of that informal institution because it had been so designed would probably no longer be moved to support it. The wishes of people, perhaps long dead, who had supported its constituent formal institutions in their aesthetic functions would no longer be honored—if, for example, the proceeds from their donations to an art museum were now being used to promote affordable housing on the grounds where the museum once stood (even supposing that their funding of the art museum had been predicated on beliefs about the worthiness of providing opportunities for the underprivileged).

Aesthetic communication would not, however, necessarily cease to occur, even though it would have lost a structure that supported and promoted it. Moreover, to the extent that an informal institution and practice has in the past successfully promoted aesthetic communication, it seems likely that, if the artworld were to be beyond recovery for aesthetic purposes, a new world and practice uniting those who still found value in participating in aesthetic communication would eventually emerge. As Kuspit says, "What has been done and seems to be dead can be brought to life again if there is a human need

for it," and his book ends optimistically with praise for contemporary painters whom be describes as "New Old Masters," for whom "art is again a means of aesthetic transcendence" (2004, 183).

If aesthetic communication is a fundamental human activity, and if practices and institutions typically grow up around persisting human activities, then the end of what we now call art as an aesthetic practice would in all likelihood be followed soon enough by the appearance of a new practice whose end, in a different sense, was aesthetic, and there would be sufficient reason to regard the rise of such a practice as the revival of art.

References

Beardsley, Monroe. 1958. *Aesthetics: Problems in the Philosophy of Criticism.* New York: Harcourt Brace.

———. 1969. "Aesthetic Experience Regained." *Journal of Aesthetics and Art Criticism* 28:3–11.

———. 1982. *The Aesthetic Point of View.* Ithaca: Cornell University Press..

Bell, Clive. 1914. "The Aesthetic Hypothesis." In *Art and Philosophy: Readings in Aesthetics,* edited by W. E. Kennick, 60–73. 2nd ed. New York: St. Martin's.

Bullough, Edward. 1912. "'Aesthetic Distance' as a Factor in Art and an Aesthetic Principle." In *Aesthetics: A Critical Anthology,* edited by George Dickie and Richard J. Sclafani, 758–82. New York: St. Martin's.

Carlson, Allen. 2000. *Aesthetics and the Environment: The Appreciation of Nature, Art, and Architecture.* London: Routledge.

Cohen, Marshall. 1962. "Aesthetic Essence." In *Aesthetics: A Critical Anthology,* edited by George Dickie and Richard J. Sclafani, 484–99. New York: St. Martin's.

Danto, Arthur. 1964. "The Artworld." In *Culture and Art,* edited by Lars Aagaard-Mogensen, 9–20. Atlantic Highlands, N.J.: Humanities Press; Nyborg, Denmark: F. Lokkes Forlag.

———. 1986. "The End of Art." In *The Philosophical Disenfranchisement of Art,* 81–115. New York: Columbia University Press.

Davies, Stephen. 1991. *Definitions of Art.* Ithaca: Cornell University Press.

Dickie, George. 1965. "Beardsley's Phantom Aesthetic Experience." *Journal of Philosophy* 62:129–36.

——. 1974. *Art and the Aesthetic: An Institutional Analysis*. Ithaca: Cornell University Press.

Foster, Hal, ed. 1983. *The Anti-Aesthetic: Essays on Post-Modern Culture*. Port Townsend, Wash.: Bay Press.

Frankel, Henry. 1998. "Aesthetics of Glass." In *Encyclopedia of Aesthetics*, edited by Michael Kelly, 2:308–11. New York: Oxford University Press.

Godfrey-Smith, Peter. 1995. "Function." In *A Companion to Metaphysics*, edited by Jaegwon Kim and Ernest Sosa, 187–88. Oxford: Blackwell.

Guyer, Paul. 1998, "Baumgarten, Alexander Gottlieb." In *Encyclopedia of Aesthetics*, edited by Michael Kelly, 1:227–28. New York: Oxford University Press.

Iseminger. Gary. 1973. "The Work of Art as Artifact." *British Journal of Aesthetics* 13:3–16.

——. 1976. "Appreciation, the Artworld, and the Aesthetic." In *Culture and Art*, edited by Lars Aagaard-Mogensen, 118–30. Atlantic Highlands, N.J.: Humanities Press. Nyborg, Denmark: F. Lokkes Forlag.

——. 1981. "Aesthetic Appreciation" *Journal of Aesthetics and Art Criticism* 39:389–97.

——. 1999. "The Aesthetic Function of Art." In *Proceedings of the Twentieth World Congress of Philosophy*. Vol. 4, *Philosophies of Religion, Art, and Creativity*, edited by Kevin L. Stoehr, 169–76. Bowling Green, Ohio: Philosophy Documentation Center.

——. 2005. "The Aesthetic State of Mind." *Contemporary Debates in Aesthetics and the Philosophy of Art*, edited by Matthew Kieran. Oxford: Blackwell.

Kelly, Michael, ed. 1998. *Encyclopedia of Aesthetics*. 4 vols. New York: Oxford University Press.

Korsgaard, Christine. 1983. "Two Distinctions in Goodness." *Philosophical Review* 92:169–95.

Kristeller, Paul Oskar. 1951. "The Modern System of the Arts." *Journal of the History of Ideas* 12:496–527; 13:17–46.

——. 1998. "Origins of Aesthetics: Historical and Conceptual Overview." In *Encyclopedia of Aesthetics*, edited by Michael Kelly, 3:416–28. New York: Oxford University Press.

Kuspit, Donald. 2004. *The End of Art*. Cambridge: Cambridge University Press.

Lewis, C. I. 1946. *An Analysis of Knowledge and Valuation*. LaSalle, Ill.: Open Court.

Lyas, Colin. 1997. *Aesthetics*. London: UCL Press.

Maquet, Jacques. 1986. *The Aesthetic Experience: An Anthropologist Looks at the Visual Arts*. New Haven: Yale University Press.

Martin, Richard. 1998. "Fashion as Art." In *Encyclopedia of Aesthetics*, edited by Michael Kelly, 2:154–57. New York: Oxford University Press.

Merton, Robert. 1957. *Social Theory and Social Structure*. Glencoe, Ill.: Free Press.

Miller, Mara. 1998. "Gardens as Art." In *Encyclopedia of Aesthetics*, edited by Michael Kelly, 2:274–80. New York: Oxford University Press.

Minneapolis Institute of Arts. 2001. "Wood Turning in North America since 1930." Exhibition catalog.

Nagel, Thomas. 1974. "What Is It Like to Be a Bat?" *Philosophical Review* 83:435–50.

Novitz, David. 1992. "Function of Art." In *A Companion to Aesthetics,* edited by David Cooper, 162–67. Oxford: Blackwell.

Putnam, Hilary. 1981. *Reason, Truth, and History.* Cambridge: Cambridge University Press.

Scruton, Roger. 1974. *Art and Imagination.* London: Methuen.

Searle, John. 1964. "How to Derive 'Ought' from 'Is.'" *Philosophical Review* 73:43–58.

——. 1995. *The Construction of Social Reality.* New York: Free Press.

Shiner, Larry. 2001. *The Invention of Art.* Chicago: University of Chicago Press.

Sircello, Guy. 1972. *Mind and Art.* Princeton: Princeton University Press.

Snyder, Joel. 1998. "Photography: An Overview." In *Encyclopedia of Aesthetics,* edited by Michael Kelly, 3:489–93. New York: Oxford University Press.

Telfer, Elizabeth. 1998. "Food." In *Encyclopedia of Aesthetics,* edited by Michael Kelly, 2:208–11. New York: Oxford University Press.

Weitz, Morris. 1956. "The Role of Theory in Aesthetics." *Journal of Aesthetics and Art Criticism* 15:27–35.

Wittgenstein, Ludwig. 1953. *Philosophical Investigations.* New York: Macmillan.

Wright, Larry. 1976. *Teleological Explanations.* Berkeley: University of California Press.

Index

advertising as promoter of aesthetic communication, 98–100

aesthetic communication
 applying the concept of, 52–55
 anticipated by eighteenth century theorists, 108–111
 paradigmatically involving someone designing and making an artifact with the aim and effect that someone else appreciate it, 25–27, 31–33
 possible cases of, discussed, 55–59
 possible cases of, to discuss, 59–61
 requires understanding, 32
 as transaction, 32

aestheticism (broadly defined), 3

aestheticism, new. See new aestheticism

aestheticism, traditional. See traditional aestheticism

aestheticism, Victorian. See Victorian aestheticism

aestheticist intuitions
 connection between art and the aesthetic, 10

connection between nature of art and principle of aesthetic value, 11
 distinction between artistically relevant and artistically irrelevant properties, 10
 necessity of experience for appreciation, 10
 summarized, 11, 119

aesthetic nonart, 70, 77

aesthetic realism, 37–38

aesthetic state of mind
 appreciation as the new aestheticism's, 26, 33–34
 traditional accounts of, 3, 6–9, 12–13, 15–17, 19–20

(AF) (principle stating a sufficient condition for attributions of artifactual function), 28, 80, 117

d'Alembert, Jean, 73, 92, 106–107

antiaesthetic art, 22, 111, 119, 135–136

appreciation
 as aesthetic, 34–35
 central to aesthetic communication, 33–34